BRYAN PETERSON'S
EXPOSURE SOLUTIONS

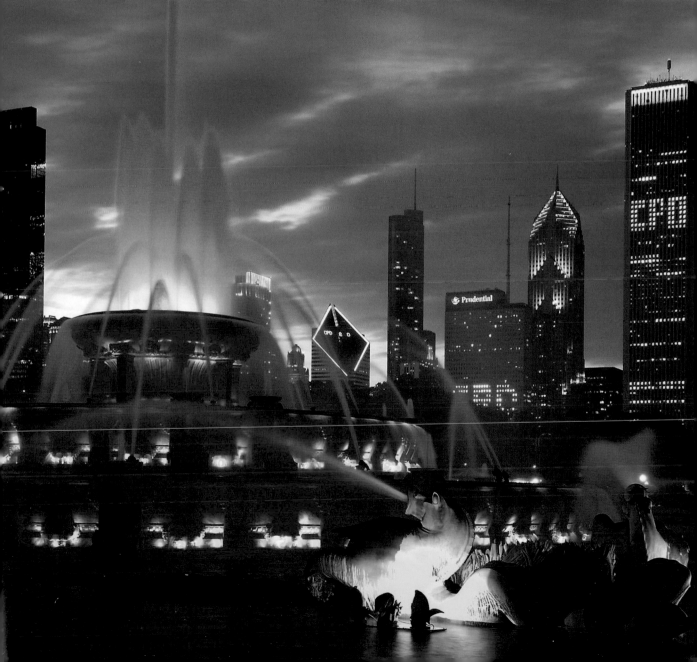

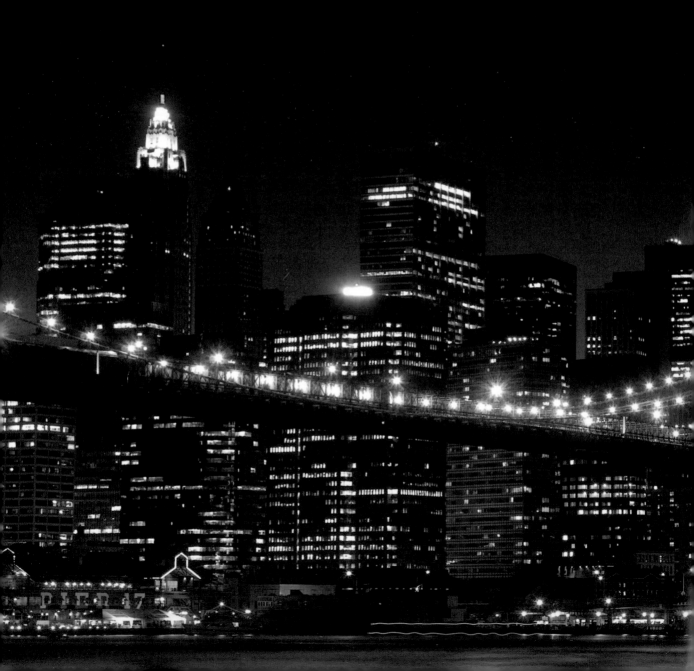

BRYAN PETERSON'S
EXPOSURE SOLUTIONS

The Most Common
Photography Problems
and How to Solve Them

BRYAN PETERSON
WITH JEFF KENT

AMPHOTO BOOKS
an imprint of the
Crown Publishing Group/New York

Acknowledgments

Thank you to my editors, Julie Mazur and Jeff Kent.
Wow, nothing gets past you guys!

Published in the United States by Amphoto Books, an imprint of the Crown
Publishing Group, a division of Random House, Inc., New York.
www.crownpublishing.com
www.amphotobooks.com

AMPHOTO BOOKS and the Amphoto Books logo
are trademarks of Random House, Inc.

Some of the photographs within this book originally appeared
in previous Bryan Peterson publications.

Library of Congress Cataloging-in-Publication Data

Peterson, Bryan
 Bryan Peterson's exposure solutions : the most common photography
problems and how to solve them / Bryan F. Peterson with Jeff Kent.
 p. cm.
 Includes bibliographical references and index.
 ISBN 978-0-7704-3305-5 (trade pbk. : alk. paper)—ISBN 978-0-307-98513-2
(ebook)
1. Photography—Exposure. I. Kent, Jeff, . II. Title. III. Title: Exposure
solutions.
 TR591.P478 2012
 770—dc23

 2012008033

Printed in China
Design by Ken Crossland
Cover photographs by Bryan F. Peterson

10 9 8 7 6 5 4 3 2 1

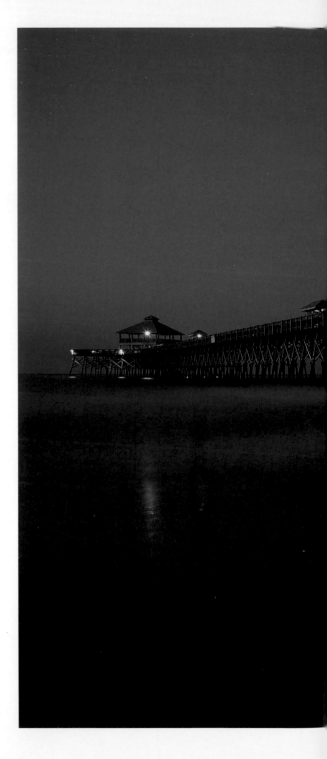

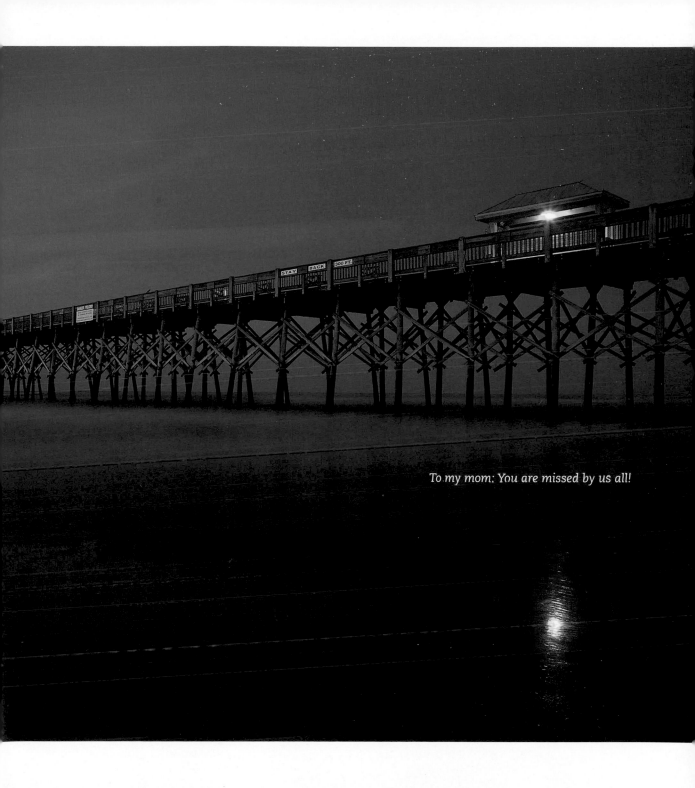

To my mom: You are missed by us all!

CONTENTS

INTRODUCTION

From my photographic beginnings, way back in 1970, I have been fascinated by the subject of exposure. Despite the massive amount of technology that has influenced photography over the past 40-plus years, photographers still struggle with exposure. For many, exposure continues to be all about light—and the lack of light. But in my mind, it is a much deeper topic. While yes, it is of paramount importance that photographers understand the simple math involved in f-stops, shutter speeds, and ISO, it's also critical that they understand the difference between a correct exposure and a *creatively* and thus *deliberately* correct exposure.

In this, my latest book on exposure, I present a condensed guide to conquering the most common exposure problems. These are the confusing situations that my students and readers have complained about for years—all clearly explained with easy-to-understand solutions so you can impose your creative will on *any* photographic scenario.

I hope you find this book both useful and entertaining. Remember, photography is fun! You shouldn't be intimidated away from pursuing your creative inspiration just because an exposure situation is a little tricky. Hopefully, with the help of this book, you can reclaim your artistic vision and become the photographer you've always wanted to be, regardless of the exposure situation thrown at you.

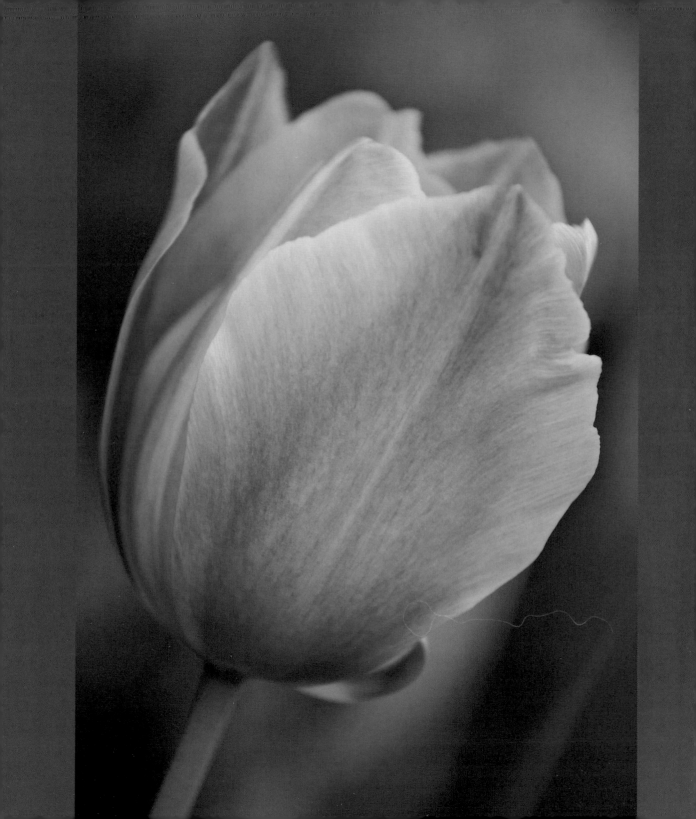

MASTERING CREATIVELY CORRECT EXPOSURES

One of the most confusing concepts for photo enthusiasts is the difference between a *quantitatively correct* exposure and a *creatively correct* exposure. You might think that as long as your light meter indicates a correct exposure at a certain exposure setting, then you're in good shape. And on one level, you'd be correct. Your light meter tells you the correct *quantitative* value for a properly exposed image. Technically, a correct exposure is nothing more than the quantitative value of an aperture and shutter speed working together within the confines of a specific ISO. This is the case whether you're in Program mode, Shutter Priority mode, Aperture Priority mode, or even manual mode. However, if you blindly follow your light meter's advice, you're giving up creative control over your image. Maybe you want to emphasize a certain part of the composition and blur out the rest. Maybe you want to express a sense of motion. Maybe you want to capture a fun lighting effect. Maybe you want to expand your depth of field for a dramatic sense of place. The options are nearly endless if you consider the *creatively correct* exposure.

A creatively correct exposure is the ideal combination of aperture and shutter speed for the artistic effect you want to produce. Most picture-taking situations have at least six combinations of f-stops and shutter speeds that will yield a quantitatively correct exposure. But typically, only one or two of these combinations will give you a creatively correct exposure. This entire book is about choosing the creatively correct exposure for different shooting scenarios. In this opening section, we'll start with the two most basic approaches to setting up a composition: storytelling exposures (deep depth of field) and single-theme exposures (shallow depth of field). You can apply many of the principles of these two exposure types to all of the other special effects you'll learn later in the book.

HOW TO MASTER DEEP DEPTH-OF-FIELD IMAGES

The Challenge

In my other books, I've discussed what I call "storytelling exposures." Storytelling exposures are, quite simply, images that tell a story. Like all good stories, these images have a beginning (the foreground subject), a middle (the middle-ground subject), and an end (the background subject). To bring all these elements into your composition, you want the maximum possible depth of field so that everything in your frame is in sharp focus. Storytelling exposures are basic building blocks of good narrative photography, but they confound many people who are unsure where to place emphasis within the composition. You might also wonder where to place your focus to achieve this effect.

The Solution

When using a digital camera with a full-frame sensor, most experienced photographers choose wide-angle zoom lenses (14–24mm, 16–35mm, 17–35mm) to shoot storytelling compositions. If using a digital camera with a partial-frame sensor, try the 11–17mm range. Wide-angle zooms are popular because they typically include the full range of focal lengths you'll need for a storytelling image. Occasionally, you might want to try a moderate telephoto (75–120mm) or one of the "normal" focal lengths (45–60mm), depending on what you want to feature in your image. But regardless of the lens choice, there is one constant when making a storytelling composition: a very small aperture of f/22, or even f/32.

Now, there may be naysayers out there who will insist that using a small aperture is a bad idea. They believe that shooting at these small apertures costs you sharpness, contrast, even color. However, I'm joined by an army of experienced photographers urging you to turn a deaf ear to these protests. If you do, you will create some of the most intimate landscapes and cityscapes you can imagine. You'll also experience the joy of sharpness from the up-close-and-personal distance of 14 inches all the way to infinity!

When you insist on *not* using small apertures yet still attempt to record intimate landscapes, your storytelling composition will lose the vital "beginning" of your story thanks to a lack of sharpness in your foreground. It's like a story without an opening paragraph. You will never record a depth of field from 14 inches to infinity at f/8 or f/11 when using a 12–16mm crop factor wide-angle lens, or if using a focal length from 17 to 24mm with a full-frame camera. Let me repeat that: You will *never* accomplish a depth of field from 14 inches to infinity at f/8 or f/11 with any DSLR!

The next important question is, where the heck do you focus? Let's say you are photographing a pastoral scene of a barn in a wheat field. If you focus on the stalks of wheat in the foreground, the barn (middle ground) and sky (background) will be out of focus. If you focus on the barn and sky, the wheat stalks will be out of focus. The solution is simple: don't focus on anything in your composition. That's right: don't focus. Instead, preset the focus via the depth-of-field scale or distance settings on your lens (see page 16 for explanations of these lens settings). Now, when I say "don't focus," what I mean is, don't compose your scene and then focus on a point within the composition. For a storytelling exposure with maximum depth of field, you want to set your aperture first, then reference the corresponding distance indicated by your depth-of-field scale or distance setting. With a small aperture (big f-stop

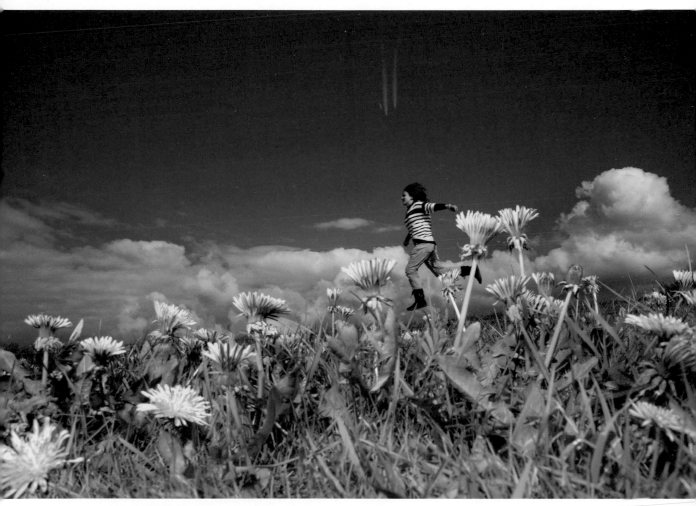

My students and I had stopped along this dandelion-covered roadside with the sole purpose of shooting storytelling imagery, and the only thing missing was a happy-go-lucky "fairy" jumping among the flowers. Olga, one of the students in the workshop, was quick to oblige. A flash provided a bit of fill light on the foreground flowers.

16–35mm lens, f/22 for 1/250 sec., Nikon SB-900 flash

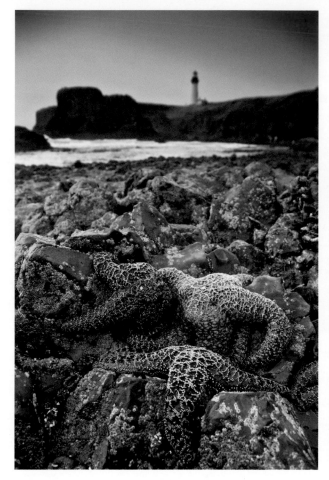 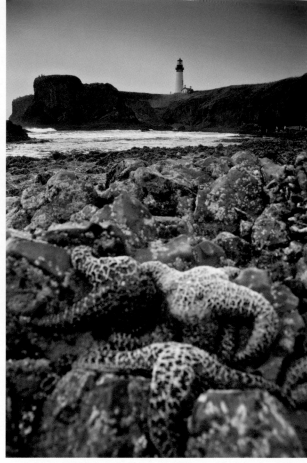

These three images were all shot with the same lens, from the same point of view, and at the same exposure in terms of quantitative value, but with different apertures and focusing distances.

In the first image (above left), I focused closely on the starfish and used an aperture of f/11. This exposure does not render a sharp background; the lighthouse and rocky bluff are out of focus. In the second image (above right), I focused on the lighthouse and shot at f/11, causing the foreground starfish to be out of focus. Only the third image (opposite) renders both the starfish and the lighthouse completely sharp because I shot at f/22 with the focus preset to 3 feet (1 meter). And therein lies the key to effective storytelling compositions!

All images: 17–35mm lens at 20mm; above left: f/11 for 1/125 sec., focused at 2 feet; above right: f/11 for 1/125 sec., focused at infinity; opposite: f/22 for 1/30 sec., focused at 3 feet

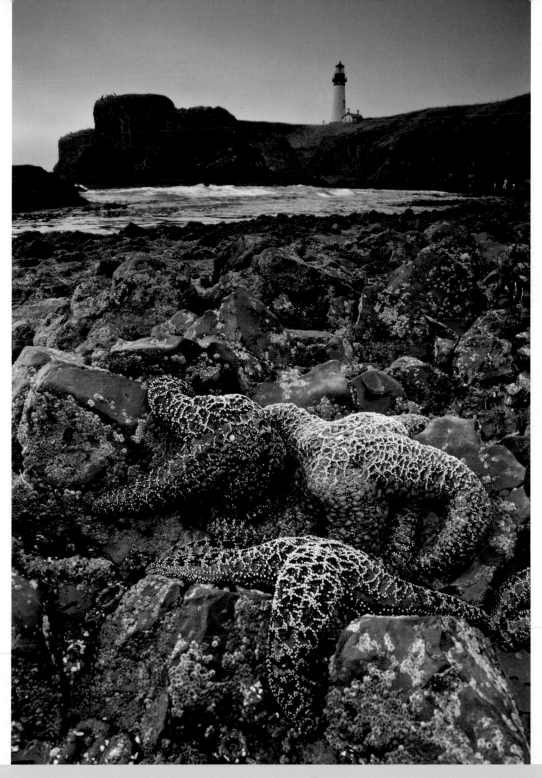

number) like f/22, your area of sharp focus will extend from a near point to infinity, so there's no need to focus on anything else in your composition. You just need to set your focus for that near point, and it will extend indefinitely. Then simply recompose with your preset focal range, and shoot!

So how do you use a depth-of-field scale, or distance settings? Single-focal-length lenses have a depth-of-field scale that makes it easy to preset your focus for a given scene. A depth-of-field scale has your lens apertures on the bottom and a series of distances, given in feet and meters, on the top, including a symbol for infinity. Simply select an aperture, then look at the corresponding distance marks on the scale. There are two marks for every aperture, which line up with two distances on the top of the scale—a near point and a far point. These near and far points are your range of focus, or depth of field. Everything between these distances will be in sharp focus. Everything outside them will be blurry. For example, an aperture of f/22 might line up with 3 feet (1 meter) on one side and infinity on the other, meaning your depth of field will reach from 3 feet on the close end to infinity on the far end. There's no need to focus on anything within this range because it will all be sharp. This depth of field is ideal for a storytelling image.

These days, however, most photographers skip the single-focal-length lenses in favor of wide-angle zoom lenses. Zooms offer great quality and a bigger bang for your buck, but there is a trade-off: they don't have depth-of-field scales. They do, however, have distance settings, which, similar to depth-of-field scales, allow you to preset the depth of field before taking your shot. Since storytelling compositions rely on maximum depth of field, set your aperture to f/22 and then align a specific distance—3 feet (1 meter) or 6 feet (2 meters), depending on the focal length you are using. You'll find these numbers above the distance-setting mark on your lens. At this aperture, if you set your focus to the near point (either 3 feet or 6

feet, as mentioned above), your depth of field will extend from that point all the way to infinity. So, again, there's no need to focus on anything in your composition. Everything between your near point (3 or 6 feet) and infinity will be tack sharp.

With all of this in mind, here is my foolproof formula for setting up storytelling compositions with a wide-angle zoom lens when you want as much front-to-back sharpness as possible.

Your first step: Turn off autofocus!

If you're using a camera with a "crop factor" and a lens with a 75-degree angle of view (18mm on a digital 18–55mm zoom lens), set the aperture to f/22 and then focus on something approximately 6 feet (2 meters) from the lens. Resist the temptation to focus toward infinity and leave your focus set to that 3- or 6-foot mark recommended above. Trust me, everything within this focus range will be tack sharp.

Next, if you're in manual exposure mode, adjust your shutter speed until a correct exposure is indicated. Then shoot. If you're in Aperture Priority mode, simply shoot, since the camera will set the shutter speed for you. Your resulting depth of field will extend from about 3 feet (1 meter) to infinity. Now you're ready to shoot!

If you're using a 12–24mm digital wide-angle zoom lens and a focal length between 12mm and 16mm, set the lens to f/22, focus on something 3 feet (1 meter) away, and repeat the final step mentioned above. Your resulting depth of field will be approximately 14 inches to infinity.

For those of you shooting with full-frame digital sensors and a focal length between 14 and 24mm, simply focus on something 3 feet (1 meter) away, set your aperture to f/22, and proceed as above. The resulting depth of field will again be 14 inches to infinity.

If you're shooting with a focal length of 25mm to 28mm on a full-frame camera, you must set the focus distance to 6 feet (2 meters). This will yield a depth of field from 3 feet to infinity.

Fortunately, this well-lit ramp, which leads one from the large mosque back toward the city of Doha, Qatar, was free of traffic when I made this photograph. As a result, I was able to set the camera and tripod low to the ground, placing emphasis on one of the many domed lights protruding above the ramp. The repeating pattern of lights suggests depth, and the resulting line leads the eye toward the distant city skyline. Compositions of this type need a deep depth of field and, as such, an aperture of f/22 was vital.

16–35mm lens, f/22 for 8 seconds

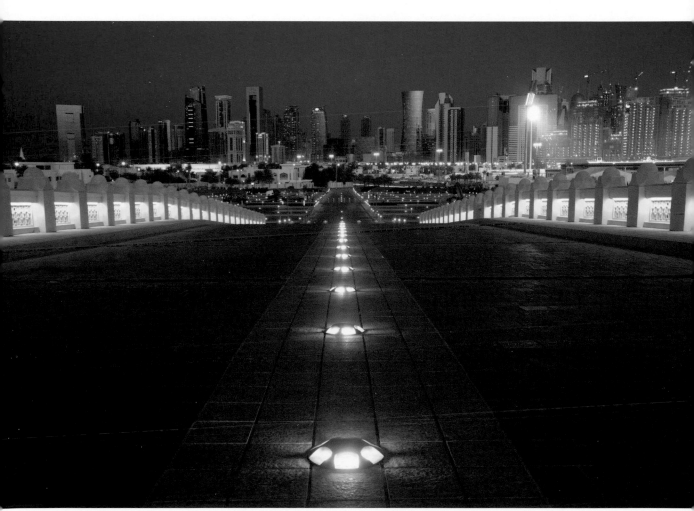

HOW TO GET MAXIMUM DEPTH OF FIELD WITH A TELEPHOTO LENS

The Challenge

When shooting with a telephoto lens, many photographers are confounded by the challenge of achieving a deep depth of field. A telephoto lens by its very design cannot encompass both an extreme foreground and an infinite background in the same composition. This is because the lens has a narrower angle of view when compared to a wide-angle lens. But great photo opportunities don't just adapt themselves to the lens you happen to have with you. If you're out with only your telephoto and a striking landscape image unfolds before you, you'll probably want to capture it with as much depth of field as possible. You may wonder if there is a foolproof formula for getting maximum front-to-back sharpness when using a telephoto lens.

The Solution

After composing a telephoto scene, stop the lens down to f/22 (or f/32 if your lens allows it). As you look through the viewfinder, adjust your focus until you have focused on a point about one-third of the way into the scene (autofocus must be turned off). Then you are ready to shoot.

Just so there is no confusion, I want to stress what is meant by a "deep depth of field" with a moderate telephoto lens, such as a 100mm lens. This focal length is capable of delivering a depth of field of approximately 30 feet to infinity when shot at the small aperture of f/32. Obviously, this is a far cry from the 3 feet to infinity you can achieve with a wide-angle lens. Also, telephotos don't offer the wide and sweeping "vision" of wide-angle lenses, about 75 to 104 degrees. Your 100mm lens offers a much narrower, 22-degree angle of view.

USING F/32

If your telephoto lens gives you the option of stopping all the way down to f/32, embrace it! As you know, the smallest aperture opening gives you the maximum depth of field. Just remember to watch your shutter speed, as f/32 may force such a slow shutter speed that you will compromise the overall sharpness of your composition. For example,

let's say it's a windy day and you do *not* wish to record the motion of the wind moving the foliage. An aperture of f/32 would generate a shutter speed of 1/15 sec., slow enough to record some blur in the leaves. If that's not what you want, back off and use f/22 instead, which will speed up the shutter speed to 1/30 sec. and keep your image sharp.

Imagine my surprise when I came upon this field of poppies in Bavaria, Germany, several years ago. Although I did not see any cows nearby, it was obvious which side of the fence the cows were allowed to graze. My attraction to this landscape was, of course, the contrast between the two fields—the explosion of poppies in the one field and the bare green, low-growing grass in the other. The meandering line of the fence also emphasizes the whimsical nature of this composition. Since I wanted to record sharpness front to back, I needed the smallest of apertures, which is f/32 on the Nikkor 70–300mm lens I was using.

With my camera and lens on a tripod, and after turning off autofocus, I manually prefocused the lens roughly one-third of the way into the scene. With my aperture set to f/32, and while framing the scene you see here, I adjusted my shutter speed until 1/15 sec. indicated a correct exposure. Fortunately, the air was still, so I did not have to wait for any breeze to die down. With the aid of my cable release, I fired off several frames. At f/32, the front-to-back sharpness is perfect.

70–300mm lens, f/32 for 1/15 sec.

HOW TO MASTER SHALLOW DEPTH-OF-FIELD IMAGES

The Challenge

In singular-theme compositions, the goal is to limit your area of sharp focus to a particular part of the frame, letting all other portions of the composition fade to soft focus. When you selectively focus on one subject, the blurry background and/or foreground calls further attention to the in-focus subject. This is a standard visual law often referred to as *visual weight*: whatever is in focus is understood by the brain to be of greatest importance.

People portraits are good candidates for singular-theme compositions, as are flowers or any other subject you'd like to single out from the rest of the scene. The principle here is called *selective focus*, and it's entirely dependent on your aperture choice. While these types of exposures aren't difficult, the proper application of selective focus can be challenging because you have only a narrow depth of field to work with. If you place your sharp focus in the wrong part of the composition, you completely change the impact of the image, and manipulating that narrow range of focus can take practice. Also, many photographers have been stumped because they tried to combine the wrong lens with the wrong aperture, making the task nearly impossible.

The Solution

Producing a strong singular-theme composition is as simple as choosing the right lens, selecting the right aperture, and focusing on the right part of the composition. Since telephoto lenses have a narrow angle of view and inherently shallow depth of field, they are often the lens of choice for singular-theme compositions. When you use a large aperture (f/2.8, f/4, or f/5.6) with a telephoto lens, you get an especially shallow depth of field.

The key is to understand your limited depth of field. Unlike the storytelling compositions on page 12, singular-theme compositions don't have an area of sharp focus that extends from a few feet to infinity. The larger your aperture (smaller f-stop number), the narrower your depth of field. In a singular-theme composition taken with a large aperture on a telephoto lens, your entire span of sharp focus can be as small as a few inches, though in most cases it will be a few feet deep. The trick is placing this area of sharp focus exactly where you want it. To do this, adjust your focus back and forth until you've placed the depth of field in the ideal location. As you twist your focus ring, areas of your frame will alternately go blurry and sharp. When that area of sharp focus lands on your intended spot, you're ready to click the shutter.

As you become more aware of your lens's ability to emphasize a subject's importance through selective focus, start seeking out backgrounds of color blocks, like a wall of graffiti, that when rendered out of focus will further emphasize the in-focus subject. As a general rule, when shooting a simple portrait against a background such as a colorful wall of graffiti, I bring my in-focus subject at least 20 feet away from the wall when using a 200mm focal length and at least 15 feet away when using a 300mm focal length. At these distances, the background quickly becomes muted and out of focus when shot at apertures of f/2.8 to f/5.6. It's also important to note that both your focused subject and the background need to be under the same lighting conditions (overcast, frontlight, sidelight, and so on) to capture both under the same exposure value.

I once heard that if you pour beer instead of water into the base of a Hollyhock flower, it will grow an additional 12 inches overnight. I have never tried this, but judging by the height of this particular Hollyhock, found in a small village in France, it must have received an entire six-pack the night before! Fortunately for me, this 12-foot-high Hollyhock was growing right next to a small flight of stairs. I climbed almost to the top of the plant and used my Nikkor 24–85mm lens to frame it against a house in the background. To isolate the flower, I combined a close-focus point of view with a large lens opening.

24–85mm lens, f/4 for 1/500 sec.

CLEANING UP THE BACKGROUND

Selective focus can also be useful when you want to blur out distracting background elements for a cleaner overall composition. Let's say you're making a portrait of your daughter, but you're faced with less-than-ideal background elements. Don't let this stop you! Affix your telephoto lens, open up your aperture, focus precisely on your daughter, and let everything else go blurry. Colors and objects will blend into one another, much like a painted backdrop, giving you an attractive, clean canvas for your portrait.

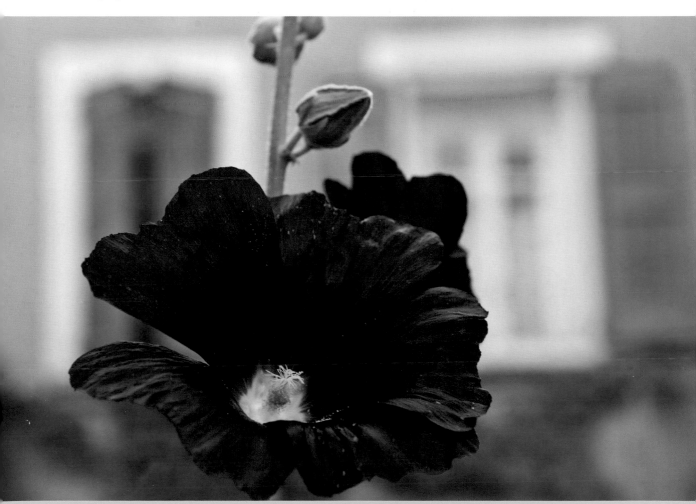

Let's look at these two portraits of Sharon, a young woman I photographed in Old San Juan, Puerto Rico. Both of these exposures are quantitatively correct, yet there is a clear visual difference in the background. In the first example (above), note the distracting wires behind Sharon's right shoulder. In the second example (opposite), the wires have magically disappeared. Did I clone them out with the aid of Photoshop? Of course not! I simply used a different combination of aperture and shutter speed that resulted in a vastly reduced depth of field. I shot the first photo at f/16 for 1/60 sec. and the second at f/4 for 1/1000 sec. Both exposures are the same in terms of their quantitative value but vastly different, as we can clearly see, in their visual weight.

Above: 70–300mm lens, f/16 for 1/60 sec.; Opposite: 70–300mm lens, f/4 for 1/1000 sec.

HOW TO USE THE DEPTH-OF-FIELD PREVIEW BUTTON

The Challenge

The depth-of-field preview button can be invaluable when determining the best aperture choice for singular-theme compositions. It offers you a preview of the depth of field you can expect based on the aperture you've selected. Simply select an aperture and then press the depth-of-field preview button.

But is it that simple? Although the depth-of-field preview button is ostensibly easy to use, it can be initially confusing. Have you tried pressing the button and everything just goes dark?

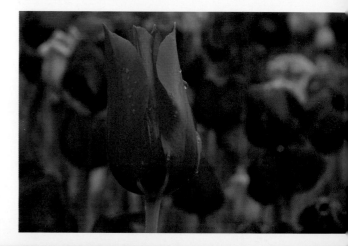

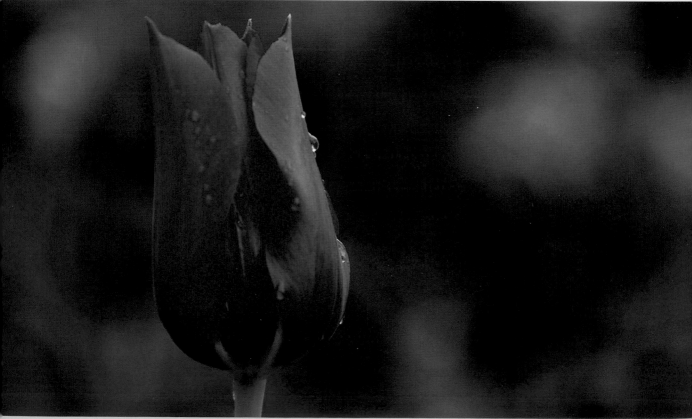

The Solution

To understand the depth-of-field preview button, try this exercise:

1. Attach a 70mm or longer lens to your camera.
2. Set your aperture to the smallest possible f-stop (f/2.8, f/3.5, or f/4, for example).
3. Focus on an object close to you, leaving enough room around it so that an unfocused background remains visible in the composition.
4. Press the depth-of-field preview button while looking through the viewfinder. Note that nothing happens.
5. Now decrease the aperture to f/8, press the button again, and take another look.

Pay special attention to the out-of-focus background. You probably noticed the viewfinder getting darker because you shrunk the lens opening, allowing in less light, but did you also notice the background becoming more defined? If not, set the aperture to f/16 and press the button again, paying special attention to the background. The viewfinder will get even darker, but that once-blurry background should be razor sharp. You're seeing the impact of aperture. Each time the aperture gets smaller, objects in front of and behind your focal point become more defined. In other words, the area of sharpness (the depth of field) extends.

If there is one bit of advice that bears constant repeating, it is this: pay close attention to your aperture choice! Many times, the wrong aperture has ruined an otherwise wonderful exposure. Take a look at the opposite image. It's a striking image of a lone tulip against a background of out-of-focus tones, shapes, and colors. This is what each and every one of us would see if we stood in this spot and shot with our 70–200mm zoom lens at the 200mm focal length with the aid of a small extension tube (a metal tube fixed between the camera body and lens to improve macro photography capabilities). However, just because this is what we would see as we looked through the viewfinder, there's no guarantee that this is what we will record on our image sensors.

If in your excitement of framing up a shot like this, you fail to notice that you are using an aperture of f/16, you will definitely record the image of this same tulip, but with a much busier background, as shown in the opposite, top image.

Fortunately, most of us have depth-of-field preview buttons on our cameras. In this scenario, I depressed my depth-of-field preview and could see right away that f/16 was offering too much depth of field. While still pressing the depth-of-field button, I increased my aperture while looking through the viewfinder, watching as the once-busy background slowly faded to blurry tones. At f/5.6, I felt the background was reduced to the softer, blurrier tones I was seeking.

Opposite, top: 70–200mm lens, f/16 for 1/10 sec.; Opposite, bottom: 70–200mm lens, f/5.6 for 1/100 sec.

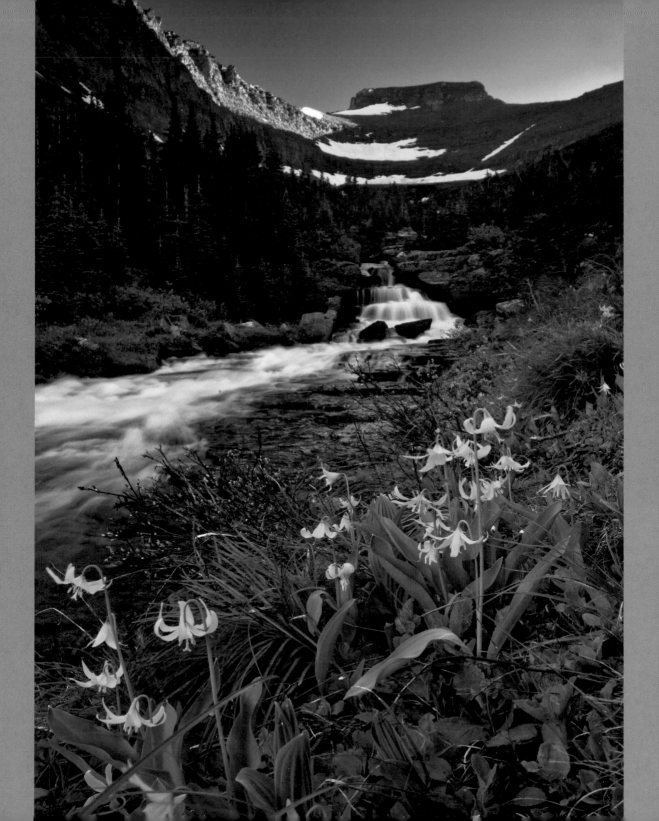

CAPTURING LANDSCAPES IN ANY CONDITIONS

Landscape photography is an almost universally popular pastime among photographers. And no wonder—there are so many photo opportunities in nature, it's hard not to spend every waking moment seeking them out. Cityscapes, too, offer opportunities to photograph the fascinating mix of natural and artificial light, man-made and natural structures.

Unfortunately, these beautiful nature scenes don't always occur in ideal conditions, and there are certain frustrating situations I hear students talk about year after year. There is the difficult backlight from a setting or rising sun and the challenge of maintaining color in a sunset while still properly exposing the foreground. Glare is a frequent problem, as are high-contrast snow and beach scenes with an abundance of white.

Fortunately, there are not only correct exposure solutions for these circumstances but *creatively correct* solutions. By following a few easy steps, you'll soon be able to master every situation Mother Nature throws at you.

HOW TO EXPOSE SPECTACULAR SUNSETS (AND OTHER BACKLIT LANDSCAPES)

The Challenge

What do you do when confronted with a gorgeous sunset over a beautiful landscape? If you expose for the brighter sky, the landscape in the foreground will go excessively dark. If you expose for the landscape, the sky will be overexposed and lose its beautiful colors. Exposure 101 states that no camera on the market today can record within a single exposure the vast range of light and dark that exists in a backlit scene. In the old days, photographers had to "grin and bear it," overexposing the backlight to bring up the foreground. Now, however, there is an easy solution.

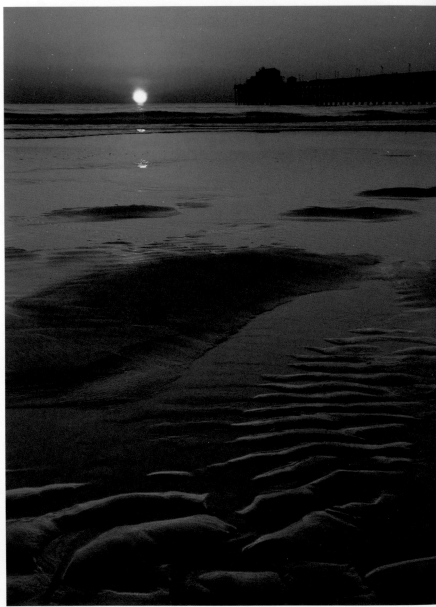

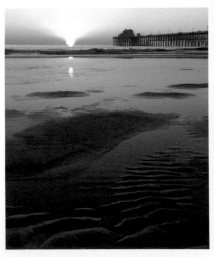

The Solution

Someone had the brilliant idea to make a lens filter that would reduce the exposure of just the backlight (sky) by several stops, thus making the background much closer to the same exposure required for the foreground. Graduated neutral-density (ND) filters have been around for years now, and they make a world of difference in compositions with strong backlighting.

Yes, Photoshop also promises to correct this type of exposure problem with a built-in graduated ND filter in Adobe Bridge, but it can make the correction only *after* you return home or to the studio. I subscribe to the belief that doing it in camera, if possible, is always the better solution.

So what do you do when you set an exposure for a backlit landscape and you don't want the foreground to go excessively dark? First, select a storytelling aperture of f/22 for a deep depth of field. Then expose for the foreground, adjusting the shutter speed until a correct exposure is indicated. Reach for your graduated ND filter, and slide the filter down into the holder on the front of your lens until the area of density covers the area from the top of the frame to the horizon line. Recompose and shoot. You will record a correct exposure of the foreground as well as the distant sun and horizon.

With my 12–24mm lens and camera on a tripod, I chose a low viewpoint to capture the texture on the sandy beach. This was going to be a storytelling image, so I set the aperture to f/22. I pointed the camera down to the sandy area and adjusted my shutter speed until 1/8 sec. indicated a correct exposure. When I recomposed to include the setting sun, the meter reading changed to indicate that a shutter speed of 1/125 sec. would be correct. I chose to ignore this new meter reading and instead placed a 4-stop graduated ND filter on the lens. The first example (opposite, left) shows the image taken without the filter; note how the sun and background sky are blown out. As the second image shows (opposite, right), the filter made all the difference.

12–24mm lens, f/22 for 1/8 sec., second image with 4-stop graduated ND filter

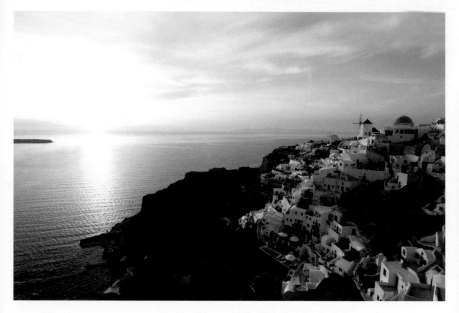

The sun was setting quickly over the Greek island of Santorini, and I wanted to capture both the beautiful sunset and some detail in the hillside homes. If I'd exposed for the sky, which called for an exposure of f/11 for 1/250 sec., the houses would have gone too dark. I wanted to show the houses in full detail, so I tilted the camera down and took a reading without the sky, filling the frame with the hillside of homes. As you can see in my first exposure of f/11 for 1/30 sec. (above), I did get the detail of the homes, but I also lost the sunset sky to a 3-stop overexposure. The solution? I placed a 3-stop graduated ND filter on the lens and slid it down until the ND portion of the filter covered the sky area. As the next image shows (opposite), I got the best of both worlds: a correct sky and a correct hillside. Talk about having your cake and eating it, too!

17–55mm lens, f/11 for 1/30 sec., second shot (opposite) with 3-stop graduated ND filter

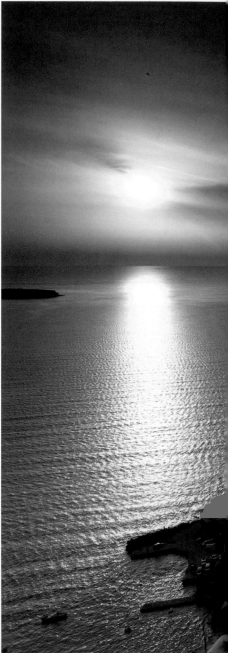

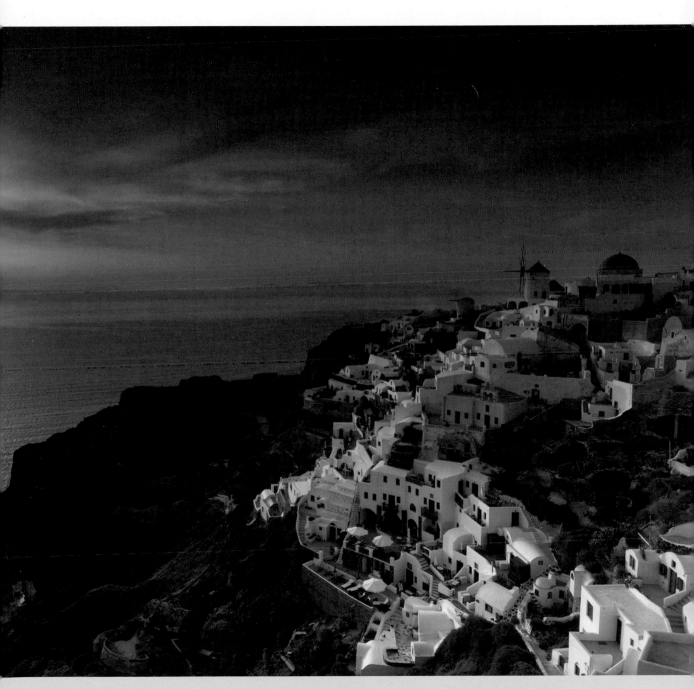

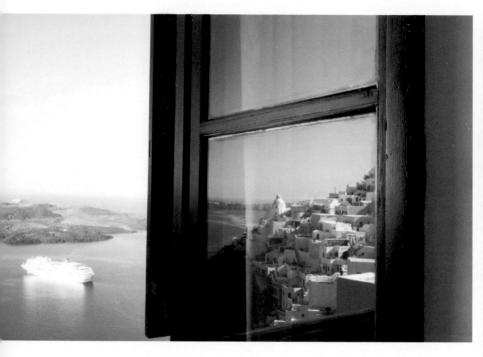

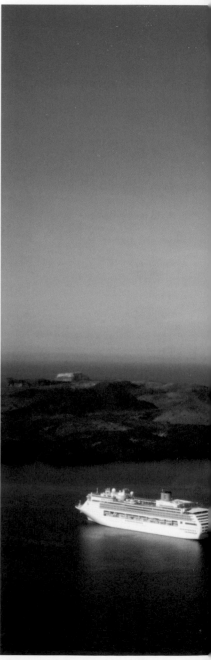

You might think that I am a teacher, but truth be told, I am a perpetual student. I enjoy learning as much as most of you. During the same trip to Santorini when I captured the previous images, my good friend Chris Hurtt, who was serving as my photo assistant, made me aware of something that is still quite memorable.

As I was shooting through this open window that showed a cruise ship in the distance and a nice reflection of the hillside homes on Santorini, I complained about the overall exposure. As shown in the first image (above), when I exposed for the darker hillside in the reflection, at f/22 for 1/30 sec., the distant cruise ship, water, and sky were overexposed.

At this point Chris spoke up. "Why don't you take your 3-stop graduated ND filter and turn it sideways?" he asked. What a great idea! And sure enough, it worked. As you can see in the second photograph (opposite), when I tilted the filter sideways so that the ND portion of it covered the distant sea, cruise ship, and sky, I got a perfect exposure with the same settings.

Above: 12–24mm lens, f/22 for 1/30 sec., second shot (opposite) with 3-stop graduated ND filter turned sideways

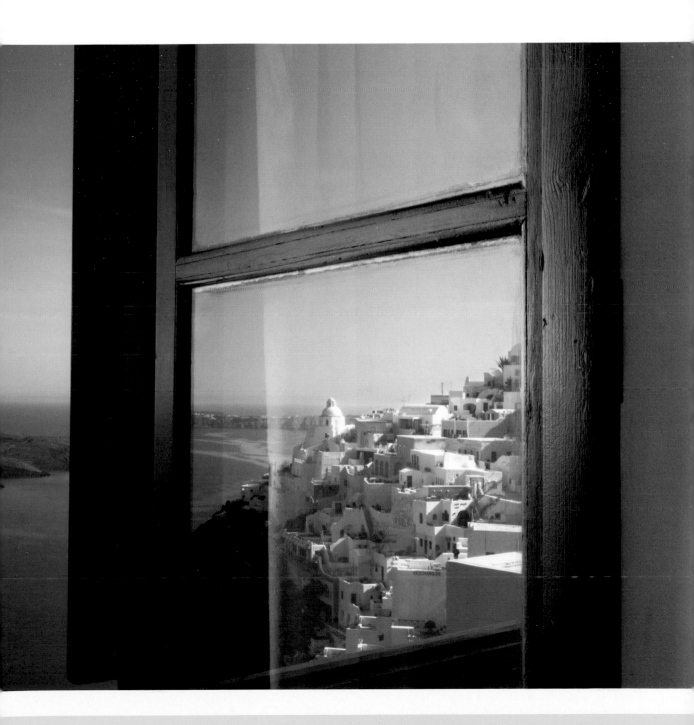

HOW TO CAPTURE STUNNING COLOR IN LANDSCAPES AND CITYSCAPES

The Challenge

Have you ever admired those brilliantly colored postcards of famous natural landmarks or iconic cityscapes? Did you ever wonder why your pictures of the same scenes look drab by comparison? If you're shooting at dawn or dusk, there is also the problem of low light. When you expose for the darkened landscape, you often blow out the sky, losing the stunning colors. But if you expose for the sky, the landscape becomes a silhouette. There's also the issue of maintaining sharpness during longer exposures necessitated by the low ambient light.

The Solution

The first thing you might need to change is what time of day you're shooting. Landscapes and cityscapes generally display more abundant color at dawn or dusk—not during the full light of day or the darkness of night. They also tend to exhibit the best natural contrast during these times. And contrary to a popular misconception, getting your exposures right in the narrow window of "magic light" at dawn and dusk is not hard at all!

In all my years of photographing at dawn and dusk, I've found there's no better—or more consistent—approach than taking meter readings off the sky. This holds true whether I'm shooting backlight, frontlight, sidelight, sunrise, or sunset. If I want a great storytelling depth of field, I set the lens (a wide-angle lens for storytelling) to f/16 or f/22, raise my camera to the sky above the scene, adjust the shutter speed for a correct exposure, recompose with my ideal composition in view, and press the shutter release. And if depth of field is not a concern, I set the aperture to f/8 or f/11 and again take a meter reading off of the sky, recompose, and shoot. When shooting city scenes at dusk or dawn, I rarely even take a meter reading anymore since most city scenes have proven to require the same exposure (when using ISO 200): f/8 for 1 second, f/11 for 2 seconds, f/16 for 4 seconds, or f/22 for 8 seconds.

Of course, for all of these longer exposures I use a tripod. This is essential. Often, I'll also employ a cable release or set the camera's automatic timer, just to make sure I'm not shaking the camera during an exposure that goes on for several seconds. I prefer the self-timer for longer exposures so that I avoid any contact with the camera. Note that your camera's default for the self-timer is usually a 10-second delay. I strongly recommend changing this to a 2-second delay for this type of photograph. Waiting 10 seconds between shots can mean missing the perfect shot entirely.

ELIMINATING CAMERA SHAKE

While we're talking about minimizing camera shake, I should note that the newest generation of super-high-resolution digital cameras employ a mirror lock-up feature to further minimize vibration. The camera's mirror flips up and out of the way when you press the shutter release, causing a minimal vibration that won't impact most images taken by most cameras. However, when dealing with the super-megapixel cameras, even minimal vibration will be magnified by the extremely high resolution. This mirror lock-up feature will likely become standard on high-end capture devices, and it's something to look for if you're shopping in that mega-megapixel range.

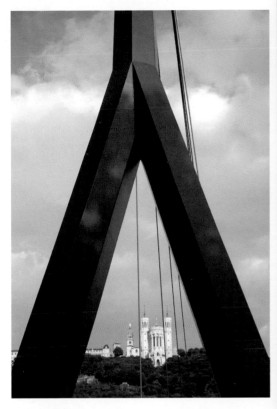

One of the many suspension bridges in Lyon, France, has a large red metal strut at each end. On the east end, you can look to the west and frame the Basilica of Notre-Dame de Fourvière atop Old Lyon through the struts. I've seen countless tourists make this shot throughout the day, but I have yet to see anyone do it at dusk. Perhaps the great restaurants of Lyon keep the tourists off the streets at dusk, but while they were dining, I was making the image shown at right, which turned out much better than the daytime shot above.

With my camera on a tripod, I set my aperture to f/22, and with the lens pointed toward the dusky blue sky, I adjusted my shutter speed until 8 seconds indicated a correct exposure. Then I recomposed the scene and set up the camera's self-timer to trigger the shutter release. (The reason I use the self-timer with long exposures is to avoid any contact with the camera during the exposure time. I don't want to risk any camera shake, since sharpness is paramount for this type of an exposure.) The long, storytelling exposure based off the meter reading from the sky produced an exposure that highlighted the rich dusk colors both in the sky and the cityscape.

Left: 35–70mm lens, f/22 for 1/60 sec; Right: 35–70mm lens, f/22 for 8 seconds

About 30 minutes before sunrise, the first hints of the dusky blue light make their presence known in the eastern sky. Thus begins a short-lived but memorable 10-minute window of blue sky where the quality of light is so magical that one can't help but come away with a compelling image. When shooting at this time of morning, natural light and artificial light are compatible, so you needn't worry about blown-out highlights.

At the Sheikh Zayed Mosque in Abu Dhabi, clear, dusky blue morning skies are the norm since it seldom rains. About 20 minutes before sunrise, the well-lit mosque and the sky are equal in exposure value. One could make the argument to shoot in Aperture Priority mode, and I would agree. However, being an old-school guy I chose to shoot in manual exposure mode, using f/22 since I wanted front-to-back sharpness. I simply aimed the camera at the dusky blue sky above and then adjusted my shutter speed until 8 seconds indicated a correct exposure. With my camera mounted on a tripod, I made the colorful exposure shown opposite. When compared to the more common image taken by tourists around ten a.m. shown at right, the colors in my dawn shot made getting up early well worth it.

Right: 16–35mm lens, f/22 for 1/60 sec.; Opposite: 16–35mm lens, f/22 for 8 seconds

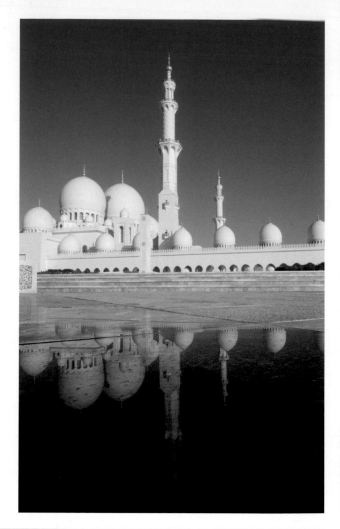

EMBRACING MAGIC LIGHT

When is magic light, exactly? In the morning, it starts at dawn and lasts until about 90 minutes after sunrise. In the evening, it starts about 90 minutes before sunset and goes until 30 minutes after sunset. In late spring or summer, this means the hours of five to seven a.m. and eight to ten p.m.—in other words, time when we're normally sleeping, eating dinner, or socializing with family and friends. Not surprising, few of us look forward to heading out with a camera at dawn! But put yourself in the mindset of an Olympic athlete and enlist the support of friends and family to help you *commit* to shooting a few times in the early morning and late afternoon magic hours. Shoot the same scene during these times of day, then go back to shoot it again in the middle of the day, between noon and three p.m. I promise that after having had this experience three times—and seeing for yourself the difference—you will rarely venture out to shoot at any other time again.

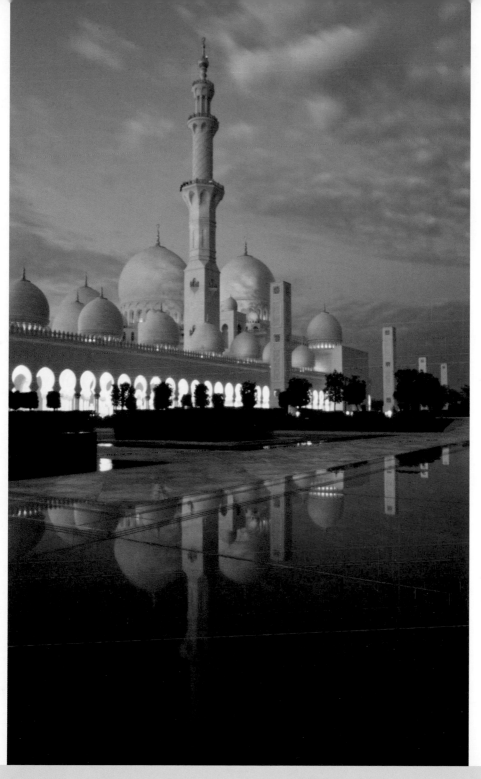

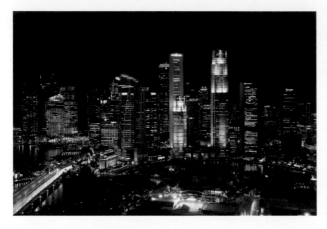

Beginning about 15 minutes after sunset and lasting for about 10 minutes, the dusky blue sky has the same exposure value as a cityscape in front of it. After this brief window, the sky goes black. Shooting city scenes against a black sky still seems to be the norm for many shooters, but the downside to photographing at night is that the dark sky does not offer any contrast or color separation.

Shooting the Singapore skyline from the balcony of my hotel room during the 10-minute window of dusky blue sky made for a far more compelling image when compared to the same shot done against a dark black sky. Because depth of field was not a concern (everything is at the same focused distance), I chose to shoot at f/11. With my camera pointed toward the sky, I registered a meter reading of 4 seconds as a correct exposure. Mounting my camera and 24–85mm lens on a tripod, I captured the first image (right).

Note that in the second exposure (above), taken 20 minutes later, also shot at f/11 for 4 seconds, the sky had gone black. There is not nearly the same separation or contrast between the buildings and the sky as seen in the blue-sky image. In the dark-sky image, portions of the skyscrapers merge into the black sky, upsetting the balance of the overall composition. The comparison of these two images makes a strong argument for shooting city skylines only until about 20–25 minutes after sunset.

Both images: 24–85mm lens, f/11 for 4 seconds

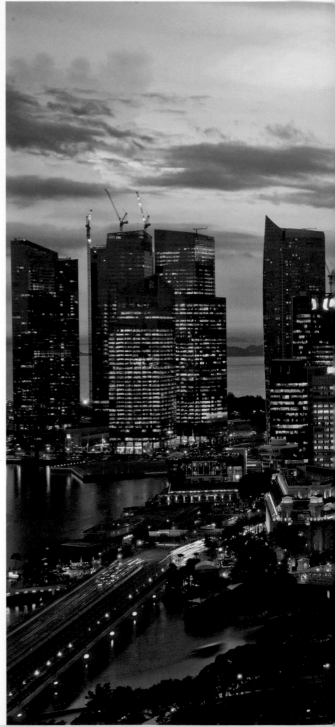

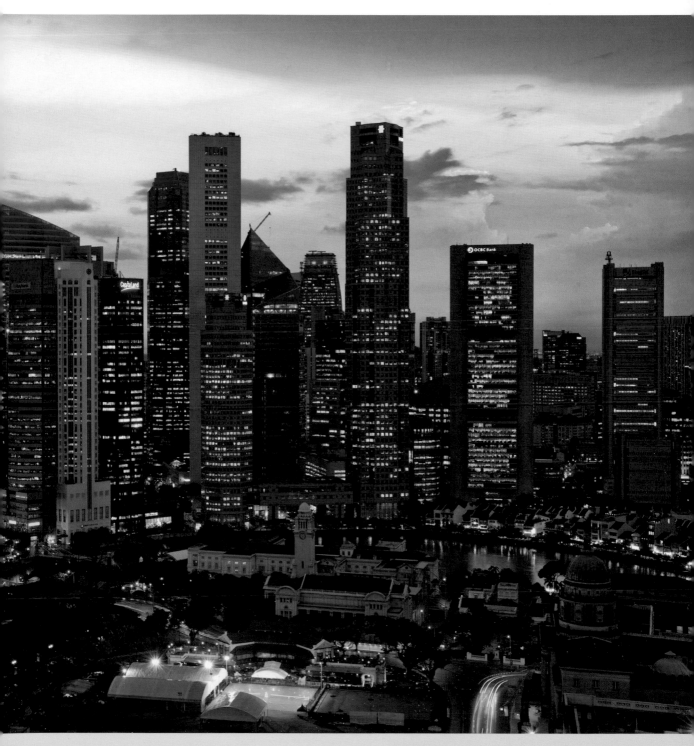

HOW TO REDUCE GLARE ON SUNNY AND CLOUDY DAYS

The Challenge

Many of us have learned to avoid shooting in bright sunlight at midday, since the light is so harsh. This aversion to midday light usually comes on the heels of shooting in early-morning or late-afternoon light, when the light is much warmer and more appealing. However, sometimes we must shoot at midday.

This frustrating light strikes reflective surfaces and bounces back up, producing distracting hot spots all over our compositions. Reflected glare also drowns out pleasing colors; your image can become grayish or washed out, with little flares around any reflective surface, including glass and metal. This problem of glare is magnified on days of heavy overcast and rain; everywhere you turn, the wet streets, sidewalks, buildings, cars, flora, and fauna are covered in a dull gray glare caused by the reflection of the dull gray sky overhead.

The Solution

Of the many filters on the market today, a polarizing filter is one that every photographer should have. Its primary purpose is to reduce glare from reflective surfaces, such as glass, metal, and water. On sunny days, a polarizer is most effective when you are shooting at a 90-degree angle to the sun (when the sun hits your left or right shoulder from the side). If the sun is at your back or in front of you, the polarizer will do you no good at all.

If you need to make images at midday, a polarizer can help no matter what direction you're facing because the sun is directly overhead. It's at a 90-degree angle to you whether you are facing north, south, east, or west.

If you're working in early-morning or late-afternoon light, use the polarizing filter whenever you shoot facing to the north or south—in other words, when you're at a 90-degree angle to the sun. As you rotate the polarizing filter on your lens, you'll clearly see the transformation; a blue sky and puffy white clouds will "pop" with much deeper color and contrast.

Why is this? Light waves move in all sorts of directions—up, down, sideways, and all angles in between. The greatest glare comes from vertical light waves, and the glare is most intense when the sun itself is at a 90-degree angle to you. The polarizing filter is designed to block out vertical light, allowing only the more pleasing, saturated colors created by horizontal light to record on your film or digital sensor.

Note that if you shift your location so that you're at a 30- or 45-degree angle to the sun, rather than a 90-degree angle, the polarizing effect will be seen on only one-half or one-third of the composition, so one-half or one-third of the blue sky is much more saturated in color than the rest of it. Perhaps you've already seen this effect in some of your landscapes. Now you know why.

First, place your polarizer on your lens and rotate the outer ring of the filter until you see the polarization effect. On clear days, you should see deeper blue skies; on overcast days, most of the gray glare should be removed. A polarizing filter cuts down the light by 2 stops, by the way, but you don't need to worry about this since your camera has through-the-lens (TTL) metering. This means that your camera's light meter *knows* that something dark, in this case your polarizer, has been placed in front of the lens, so the metering will ask for a shutter speed 2 stops slower than the normal exposure to compensate for the reduced light. Depending on your ISO, the time of day, and even the weather, the slower shutter speed may necessitate a tripod and either a cable release or the camera's self-timer.

Since my point of view was at a 90-degree angle to the early-morning light, which hit on the scene from my right, this image of the small town of Puimisson in Provence, France, offered a great opportunity to use my polarizing filter. In the first example (below), I didn't use the filter, and you can see the overall haze, the lack of blue sky, the absence of detail in the sky, and the somewhat flat greens of the trees and bushes. In the second image (right), with the polarizing filter, the difference is clear. The once flat sky became a vivid blue and the colors in the field, trees, and bushes are more brilliant.

Below: 24–85mm lens, f/16 for 1/125 sec.; Right: 24–85mm lens, f/16 for 1/30 sec. with polarizing filter

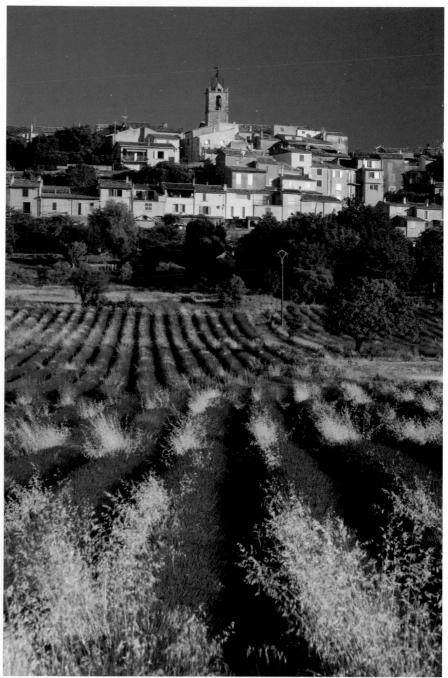

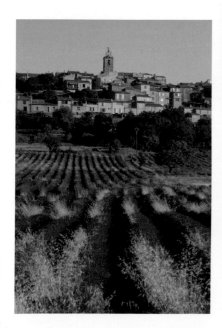

Is the use of polarizing filters limited to sunny days? Definitely not! In fact, on cloudy or rainy days, there's just as much vertical light and glare as on sunny days. All this vertical light casts a dull reflective glare on wet streets, metal, glass surfaces, wet foliage, and the surfaces of bodies of water, including streams and rivers.

A polarizing filter gets rid of this dull gray glare and is a must-have item in my camera bag more on rainy days than sunny ones. It's the one tool that will save you each and every time you shoot in the woods on a rainy day. It can remove the glare from your rainy-day compositions better than Photoshop ever will! In the first image (right), shot without the polarizing filter, note the glare on the wet leaves, rocks, moss, and water. These surfaces are reflecting the dull, gray, rainy sky overhead. But as you can see in the second image (opposite), made with the filter, the scene becomes a colorful world that only seconds ago was awash in glare.

Because the polarizing filter had cut down the light by 2 stops, I found myself using a shutter speed that was 2 stops slower. This reduction in the light was of course picked up by the in-camera meter, and I simply adjusted my shutter speed until a correct exposure was indicated. With a shutter speed of 1 second, I needed a tripod to brace the camera. I also used the camera's self-timer to fire the shutter release without risking any camera movement.

Right: 24mm lens, f/22 for 1/4 sec.;
Opposite: 24mm lens, f/22 for 1 second
with polarizing filter

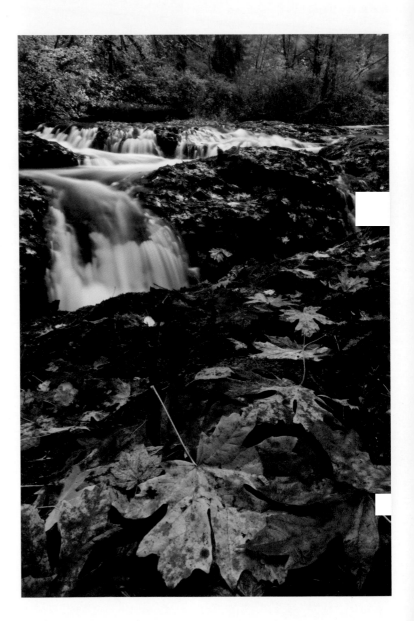

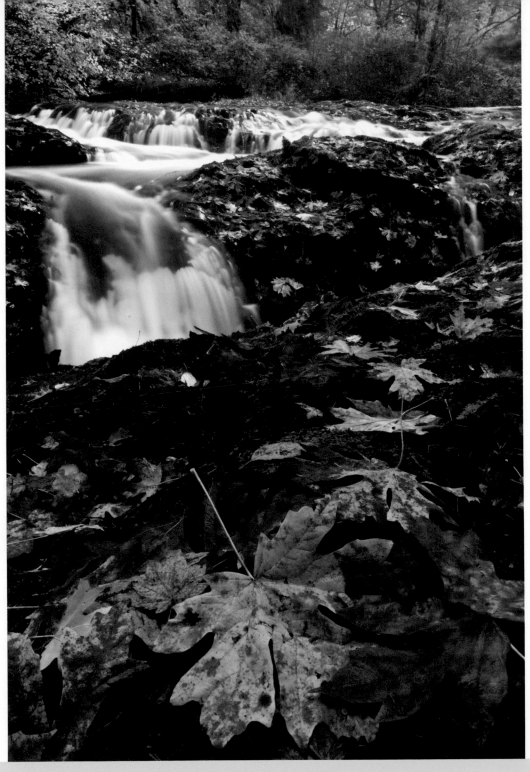

HOW TO EXPOSE HIGH-CONTRAST SCENES

The Challenge

Your camera's light meter (regardless of the setting) does not "see" the world in either living color or black and white, but rather as a neutral gray. Because of this, it *always* prefers to offer up exposure combinations that result in neutral-gray exposures. Why is that? It is because your camera's light meter was calibrated by the camera manufacturer to make calculations based on two factors: (1) the world is neutral gray, and (2) all subjects reflect back approximately 18% of the light illuminating them.

This sounds simple enough, and it works about 90% of the time, since most of the world is neutral gray in terms of its reflectance. However, this same reflectance of light (or absence of reflected light) can also create a bad exposure when you try to photograph high-contrast scenes. When presented with either a white or a black subject, the light meter freaks out. *Sound the alarm! We've got a problem!* White and black violate everything the meter was "taught" at the camera factory. If we think of gray as the middle of a metering scale, white and black are at opposite ends. In response to excessively bright (white) or excessively dark (black) subjects, the meter offers an exposure that I promise will result in that black cat becoming gray (overexposed) or the white wall becoming gray (underexposed). Neither result is surprising since, as I mentioned, the meter is just doing its job, making sure everything in the world does, in fact, record as gray.

Unless you take charge of your light meter and override the meter reading, you will forever be frustrated with "dark" exposures of white snow, brides, and white sandy beaches, and "bright" exposures of black dogs and dark-skinned subjects.

Solution #1: Override Your Light Meter

To successfully meter white and black subjects, treat them as if they were neutral gray, even though their reflectance indicates otherwise. In other words, meter a white wall that reflects 36% of the light falling on it as if it reflected the normal 18%. Similarly, meter a black cat that reflects only 9% of the light falling on it as if it reflected 18%. So how do you do that, exactly?

Let's say, for example, your camera's meter offers an exposure of f/11 for 1/250 sec. for a white wall (36% reflectance). Before shooting, slow down the shutter speed to 1/125 sec.—as if it were reflecting only 18% of the light. This extra shutter speed stop will allow in more light to record the wall as white instead of gray (as it would have at 1/250 sec.). Likewise, when metering a portrait of your black Labrador retriever, let's say you get an initial meter reading of f/11 for 1/60 sec. (9% reflectance). Before you shoot, quicken the shutter speed to 1/125 sec.—as if it were reflecting 18% of the light. This will allow in *less* light and record the dog as black instead of the gray it would have been at 1/60 sec. So, as a general rule, when faced with white subjects, *increase* your exposure by 1 stop. When faced with really dark or black subjects, *decrease* your exposure by 1 stop.

Solution #2: Meter off of the Blue Sky

If you're shooting on a clear day, perhaps the simplest way to approach a high-contrast scene is to take a meter reading from a blue sky, which almost always reflects back 18% of the light. The built-in light meter found in most cameras will either set an exposure or recommend an exposure based on

the light reflecting off any subject. It assumes that all subjects reflect about 18% of the light that hits them. Besides a gray card, a clear, blue, frontlit sky almost always measures an 18% reflectance when metered about 30 degrees above the horizon. So if a white subject or dark subject is in that same frontlight, you can safely meter off of the blue sky and use that same exposure setting for the white or dark subject nearby.

Solution #3: Meter off of a Gray Card

When I first learned about 18% reflectance, it took me a while to catch on. One tool that enabled me to understand it was a gray card. Sold by most camera stores, gray cards come in handy when you shoot bright and dark subjects, such as white sandy

If ever there was a time to shoot in manual, a snow-covered landscape would be it. Since depth of field is not a concern for this image, I set the aperture to f/8 and adjusted the shutter speed until my light meter indicated a 1-stop overexposure. As this image of my son jogging clearly illustrates, a 1-stop overexposure ensures that snow comes out white, rather than grey.

12–24mm lens, f/8 for 1/320 sec.

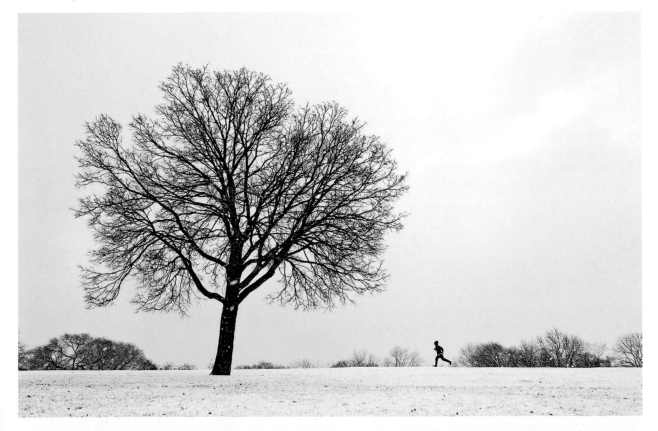

beaches, snow-covered fields, black animals, black shiny cars, and dark-skinned subjects. Rather than pointing your camera at the subject, simply hold a gray card in front of your lens—making sure the light falling on the card is the same light that falls on the subject—and set your exposure for the light reflecting off the card.

If you're shooting in an autoexposure mode such as Program, Shutter Priority, or Aperture Priority, you must take one extra step before putting the gray card away. After you take the reading from the gray card, note the exposure. Let's say the meter indicated f/16 for 1/100 sec. for a bright snow scene. In Aperture Priority mode, chances are that the meter reads f/16 for 1/200 sec. In Shutter Priority mode, the meter may read f/22 for 1/100 sec. In either case, the meter is now "off" 1 stop from the correct meter reading taken from the gray card. You need to recover that 1 stop by using your autoexposure overrides.

Depending on your camera, these overrides are designated as follows: +2, +1, 0, –1, and –2; or 2X, 1X, 0, 1/2X, and 1/4X. So, for example, to provide 1 additional stop of exposure when shooting a snowy scene in the autoexposure mode, you would set the autoexposure override to +1 (or 1X, depending on your camera's make and model). Conversely, to stop the exposure *down,* such as when shooting a black cat or dog, you'd set the autoexposure override to –1 (1/2X).

Solution #4: Meter off of the Palm of Your Hand

One of the simplest ways to arrive at a correct exposure for *any* subject—white, black, or even gray—is to take a meter reading from the palm of your hand. You'll still need a gray card at the very start, to calibrate your palm, but once you've done that, you can leave the gray card at home.

To calibrate your palm, take your gray card and camera into full sun and set your aperture to f/8. Fill the frame with the gray card (it doesn't have to

be in focus), and adjust your shutter speed until a correct exposure is indicated by the camera's light meter. Now, hold the palm of your hand in front of your lens. The camera's meter should read that you are about +2/3 to 1 stop overexposed. Make a note of this. Then take the gray card into open shade. Set your camera to an aperture of f/8 and again adjust the shutter speed until a correct exposure is indicated. Then, as before, meter your palm and you should see that the meter now reads +2/3 to 1 stop overexposed. No matter what lighting conditions you do this process under, your palm will consistently read about +2/3 to 1 stop overexposed from the reading of a gray card. (If your palm meters a 2-, 3-, or 4-stop difference from the scene in front of you, you're either taking a reading off the palm of your hand in sunlight, having forgotten to take into account that your subject is in open shade, or you forgot to take off your white gloves.)

Once your palm is calibrated, you can use it to set the exposure of any scene, sun or shade. Just hold your palm out in front of your camera, in the same light as your subject, and meter off your palm. Then use your overrides (as on page 44) to add +1 stop of exposure or, if in manual exposure mode, add +1 either via shutter speed or aperture. Then fire away! Remember, for most of us, our palms when metered at +1 equal a gray card's 18% reflectance.

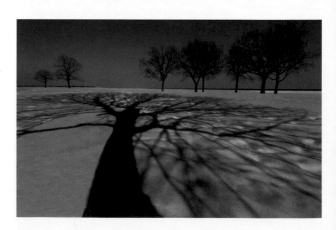

Handholding my camera and using manual exposure mode, I framed up this idyllic winter scene just off Chicago's Lakeshore Drive. After choosing f/22, I adjusted my meter until 1/200 sec. indicated a correct exposure. Not surprisingly, my photograph showed gray snow, as you can see in the first example (below left). I would have gotten gray snow even if I had shot in Aperture Priority mode. The light meter was simply doing its job, making excessively bright (white) subjects gray.

But if you have any intention of recording pure white snow, you need to perform an "intervention" and use the blue sky as a metering target. With a focal length of 14mm and a storytelling aperture of f/22, I pointed the camera to the blue sky above and then adjusted my shutter speed until the camera's meter indicated a correct exposure at 1/60 sec. Then I recomposed my original composition and voilà! I got my white snow (below). Of course, after I metered the blue sky and recomposed the snow scene before me, the LEDs of my light meter were screaming that my settings were wrong. Just like when a two-year-old throws a tantrum, I simply ignored the screaming.

12–24mm lens, f/22 for 1/60 sec.

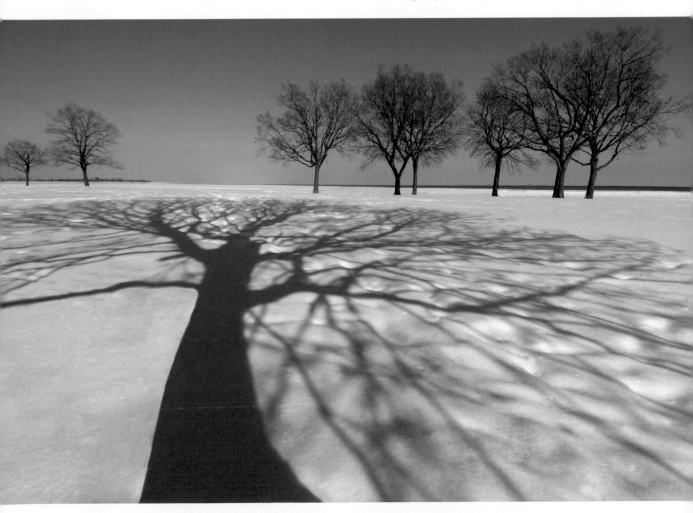

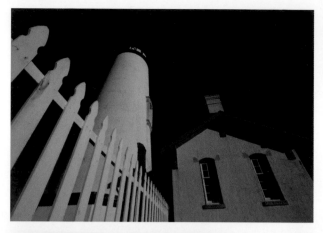

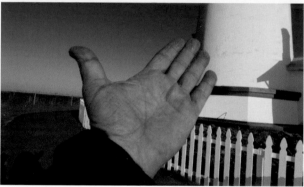

Just like many brides on their wedding day, many lighthouses "wear" white, and this can spell trouble. Unless you want to record gray brides and lighthouses, you need to take charge of your exposure. When I simply aimed, focused, and set my exposure using the camera's light meter (f/11 for 1/500 sec.), it was severely underexposed (above, top). The excessive brightness of the white lighthouse freaked out the light meter and caused it to generate an exposure that turned white to gray. With my hand extended in front of the camera, I metered off of my palm and set my exposure to +1 from the light reflecting off of my palm (f/11 for 1/200 sec.). When I photographed again using these settings, I got my pure white lighthouse (right).

Above: 17–35mm lens, f/11 for 1/500 sec.; Right: 17–35mm lens, f/11 for 1/200 sec.

PHOTOGRAPHING MOTION

Almost every moment, no matter how big or small, occurs in a state of motion. All of this motion translates into energy, and a well-executed photograph that conveys this energy is filled with what I call *e-motion*. This e-motion appeals to our psychological need for movement under our feet. Perhaps that is why on-the-go photographers enjoy such great mental health! We are pushed to record and create, and no other image is more life-affirming than one filled with e-motion. These are the images that validate "life on the move" with the greatest of exclamations.

There are many ways to impart the energy of motion into your photographs, each with its own unique challenges. Here are the ones I've found most likely to be stumbling blocks, with tips on making them work for you.

HOW TO CAPTURE SUPERSHARP ACTION SHOTS

The Challenge

There is, perhaps, nothing more satisfying than an image of action frozen in crisp, sharp detail, allowing us the time to scrutinize and analyze every nuance, down to the smallest speck. The challenge, of course, is freezing that action in the crispest detail while still maintaining a good overall exposure. Photographers commonly misjudge the shutter speeds needed for sharp, action-stopping shots. If you use one that is too fast, you'll be forced to use a larger-than-necessary aperture, compromising the depth of field and possibly sacrificing sharp detail. If you use a shutter speed that is too slow, you'll cause blurring in the subject.

The Solution

The key to sharp action shots is shutter speed. If I came to your house and chatted with you for a whopping 1/100 sec., you would no doubt say, "Well, he was here, but he was gone in the blink of an eye!" And why not, since 1/100 sec. is pretty darn quick. Just how fast is 1/100 sec.? Believe it or not, it is ten times faster than the blink of an eye, which averages around 1/10 sec. So you'd think that 1/100 sec. would be plenty fast enough to freeze action, but you'd be wrong.

On the other side of the coin, there is a widely held belief that extremely fast speeds—1/2000 to 1/4000

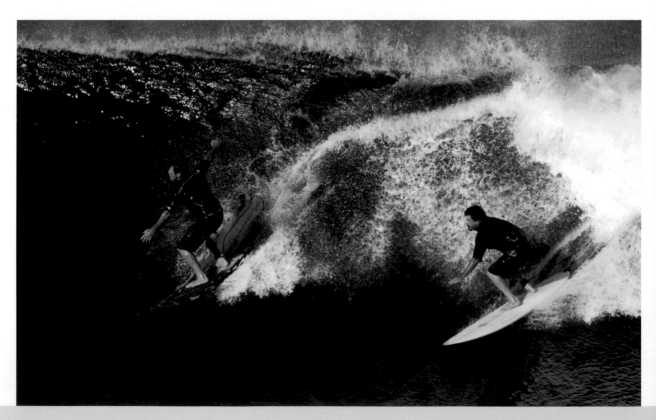

sec.—are needed to capture outdoor sports, but that is not true either. During the late 1960s and most of the 1970s, SLR cameras had a maximum shutter speed of a 1/1000 sec. Yet rarely did anyone hear a *Sports Illustrated* photographer complain that he missed a shot because 1/1000 sec. wasn't fast enough.

Most outdoor sports action shots can easily be recorded at shutter speeds of 1/250 to 1/1000 sec. And for many experienced shooters, the key to getting good exposures at 1/250 or 1/1000 sec. is the direct result of using the right ISO. High ISOs make it easier to employ action-freezing shutter speeds. Also, with the higher ISOs you can use smaller lens openings for a greater depth of field. The greater your depth of field, the larger your area of sharp focus, and the easier it is to maintain tack-sharp focus on your subjects as they move around. However, with today's advanced autofocus features, keeping them in focus is rarely the problem. That extra depth of field might not be necessary, so shutter speed remains the primary exposure concern.

Another consideration is distance. Here's an easy way to tell if you're close enough: Is your frame at least 75% filled with the subject? If not, get closer.

The next consideration is the direction of the action. Is it coming toward you? Is it moving side to side? Or is it traveling up or down? When action is coming toward you or moving away from you, you can get away with a shutter speed of 1/250 sec. When the action is moving side to side, your shutter speed should be faster, between 1/500 and 1/1000 sec.

While shutter speed is the crucial element for a good stop-action exposure, whether or not you capture the desired action has more to do with timing than shutter speed. As such, your most useful tool is a motor drive. Some cameras come with built-in motor drives (also known as Burst mode or Continuous Shooting mode), which automatically fire a rapid succession of exposures for as long as you depress the shutter release button. This gives you a better chance of capturing that peak moment. You can begin firing the shutter several seconds ahead of the peak action and continue until a second or two after the action has stopped. It's a safe bet that one, if not several, exposures will be successful. Without a motor drive, it can be hit or miss as you try to anticipate the exact moment to shoot.

While at the dive shop across from our hotel on Maui, Hawaii, I overheard a couple of "dudes" talking about "some big swells coming in on the North Shore tomorrow." I asked if that meant the surfers would be out, and they both enthusiastically responded, "Oh yeah!"

Arising early the next morning, I found the perfect shooting location. Within 30 minutes, several surfers had arrived, along with 20- to 30-foot waves. Soon, more than 20 surfers had accepted the challenge offered up by these thunderous and sometimes unforgiving waves.

With my camera and 200–400mm Nikkor zoom lens mounted on a monopod, and my ISO set to 100, I set my shutter speed to 1/1000 sec. Pointing my camera up at the blue sky, I adjusted the aperture until f/5.6 indicated a correct exposure. A clear blue sky is a great place to take a meter reading when shooting high-contrast, frontlit scenes like this, with so much white in the waves. White is a killer when

it comes to exposure, as it reads far too bright for most light meters to measure properly, resulting in an exposure that looks more gray than white. To avoid this, I take a reading from the blue sky, about 30 degrees above the horizon, since it's neutral insofar as not being too dark or too light. (For more about this, see How to Expose High-Contrast Scenes, page 44.)

With the surfers moving at such a frantic pace, I switched my autofocus mode to AF-Servo mode, which meant that my Nikon camera would continuously keep my subjects in focus as I tracked them inside my viewfinder, and fired in Burst mode at roughly six frames per second. Although I was shooting for less than an hour, I managed to record a number of exciting images, with most of the credit going to the surfers for providing such spectacular action.

200–400mm lens, f/5.6 for 1/1000 sec.

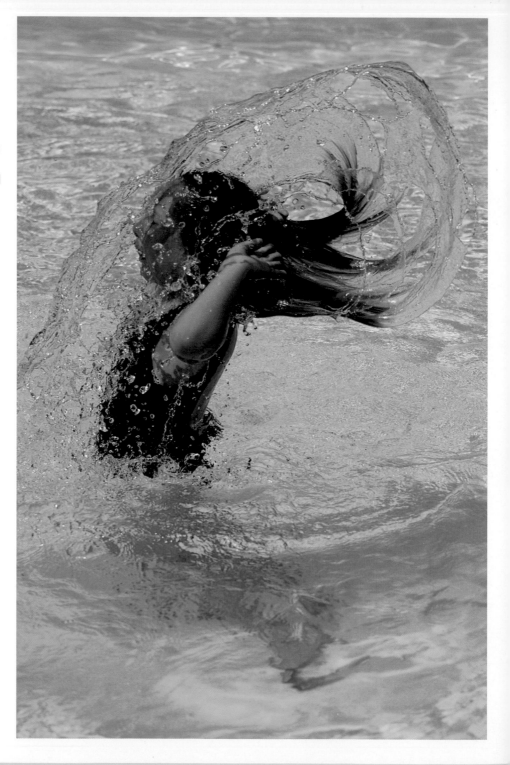

Although it took some negotiating (translation: ice cream), my daughter Chloë indulged my request to throw her head back several times so that I could photographically freeze the action of her long, wet hair flying backward with water flying off.

Because I wanted an action-stopping shutter speed of 1/800 sec. and a medium depth-of-field aperture of f/11, I had to raise my ISO to 400. Telling her to stay in the same spot and not move her feet when she came up from underwater allowed me to prefocus as well as pre-compose the shot. (The medium depth of field increased the area of sharpness, covering me if she moved a few inches closer or away from my point of prefocus.) On the count of three, I was ready, and this is the result, an action-stopping, sharply focused image of a day at the pool.

80–200mm lens, f/11 for 1/800 sec.

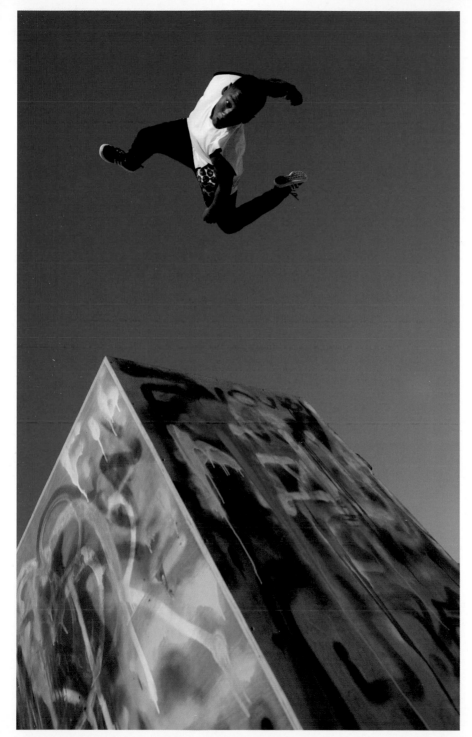

I saw them from a distance, a group of kids jumping off a large wooden box near downtown Doha, Qatar. After being informed that jumping off boxes was a new art form, I crouched down near the base of the box and looked up through my wide-angle lens at the jumpers. Because of my close proximity to the action and the erratic movements of the jumpers, I needed a shutter speed of at least 1/1000 sec. (Shutter speeds of 1/500 sec. or slower would have recorded some degree of blurring owing to the high rate of speed with which they were launching off the box and my close proximity to their antics.) With my camera set to 1/1000 sec. in shutter priority, I framed the frontlit box and blue sky overhead. Over the course of the next 15 minutes, half a dozen courageous young men leaped and spun and flipped and turned their bodies into a number of surprising contortions.

16–35mm lens, f/8 for 1/1000 sec.

HOW TO FREEZE ACTION IN LOW LIGHT

The Challenge

Freezing action in low light is an ongoing challenge for many photographers. How can you get a fast enough shutter speed to freeze action without underexposing the image or having to use such a wide aperture that you lose all depth of field? And what about flash? A flash burst will freeze action, but is it effective for a subject that's more than a few feet away?

The Solution

Let's say you're at a basketball game in a high school gym. There would be no point to using a flash. You simply wouldn't have enough light power to illuminate your subject and the surrounding scene. Instead, shoot with a high ISO and available light.

If you use a modern DSLR with ISO 3200 and your white balance on automatic, the standard exposure to use is f/4 for 1/250 sec.—no flash required. Granted, f/4 will not get you much depth of field, but in these situations, aperture needs to take a backseat to shutter speed, since it is the shutter speed that freezes the action. Also, 1/250 sec. is the minimum choice for freezing action. If you have a lens that offers f/2.8, consider this wider aperture, as it will kick up your shutter speed a whole stop to 1/500 sec.

By the end of the game, not only will you have captured some great action shots, but they'll also have a fine grain due to the low-noise capabilities of most modern DSLRs. Most gyms and stages are lit well enough that recording acceptable handheld exposures is possible. It's as if the camera manufacturers are in a constant race to see who can deliver the highest ISO without a truly noticeable drop-off in overall color, contrast, and distracting digital noise. Nikon had been leading the ISO charge, but recently the likes of Canon, Pentax, Sony, Panasonic, and Olympus have caught up with and in some respects even surpassed Nikon.

Taking advantage of these low-noise, high-ISO capabilities is certainly not limited to the gymnasium. Any indoor scene with moving subjects can benefit from this shooting technique. Next time you're hosting an indoor birthday party, turn up the

WHEN TO USE HIGH ISO VERSUS FLASH?

The high ISOs found in many cameras today allow you to handhold your camera, even in low light, for properly exposed images with low noise. This is all great but has left many photographers confused. When is it better to use a high ISO with natural light, and when should you use a flash?

It's important to understand that the low-noise, high-ISO approach deals only with brightness levels. It provides little help for poor-quality lighting. If the ambient light is not flattering on your subjects, a higher ISO can't help you. Then it's time to use the flash. For example, if you've ever tried to take a portrait outside at high noon, you know that the direct overhead sunlight creates dark under-eye shadows (aka "raccoon eyes"). This effect can also occur indoors when the light source is straight above the subject. In both of these situations, you'd want to use fill flash to provide supplemental light on the faces and eliminate the raccoon eyes.

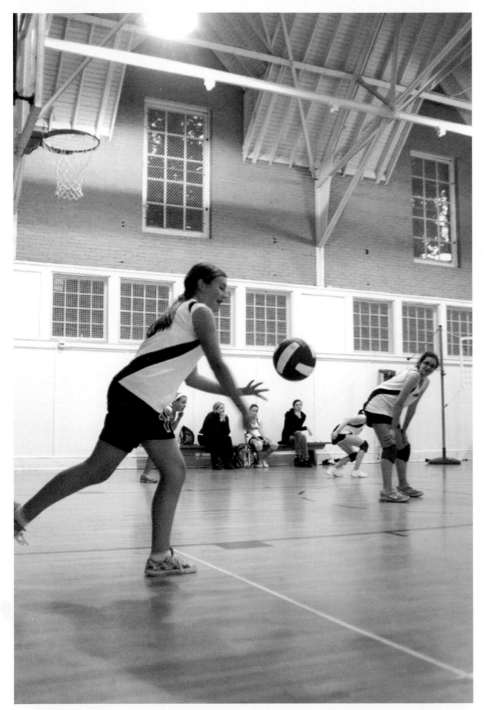

Like many parents today, I am faced with photographic challenges that revolve around indoor sports activities, many of which involve freezing motion in low-light situations. When it comes to indoor volleyball and basketball, I prefer to use the highest ISO in lieu of a flash. In the photograph you see here, I was on the sideline at one of my daughter Sophie's volleyball games. Handholding my Nikon D300S with my ISO set to 6400, I easily shot correct exposures at f/4 for 1/320 sec. with my 16–35mm Nikkor zoom lens. A no brainer! Had I tried to light up the entire gym with my single Nikon SB-900 flash, I would have been assured of recording very cavelike exposures thanks to the inverse square law (see tip, page 58).

16–35mm lens, f/4 for 1/320 sec., ISO 6400

lights in your house, set your camera to ISO 3200 and your white balance to automatic, and, with your lens aperture set at or near wide open, shoot away!

An alternative to using a high ISO is, of course, to use your flash. Flash allows you to freeze action even with a slow shutter speed. Why? Because the flash becomes your sole light source. It fires at a burst rate of up to 1/4000 sec., freezing the action of the moving subject at that same 1/4000 sec.!

To use flash, first set your camera in manual mode. Decide if you have any depth of field concerns and choose an aperture accordingly. Then, dial the aperture in to your flash. Now look at your flash. What is the flash-to-subject distance indicated for that particular aperture? Does it match the distance you are from your subject? Finally, set your shutter speed to 1-1/3 stops *under*exposed. As your subject flies, jumps, leaps, dances, or vaults before you, press the shutter release and voilà! You just froze action in low light.

UNDERSTANDING THE INVERSE SQUARE LAW

As it relates to photography and lighting, the inverse square law states that an object twice as far from a source of light will receive a quarter of the illumination. So if you're shooting your daughter's basketball game or your son's high school play, when the distance between your flash and the subject doubles, that subject receives only a quarter of the light, not half. If your hoops-playing daughter moves from 12 feet to 24 feet away, you will need four times the light to achieve a good exposure at the same camera settings. The light falloff around the subject will also be more severe, creating a cavelike look where the subject is illuminated but the surrounding scene looks like a dark cave. With the math and adjustments involved in good flash photography of moving subjects indoors, you can see why shooting with a high ISO versus flash is a lot easier and more effective.

I found myself in Doha, Qatar, shooting the Arab League Games in December 2011. I am not a sports photographer, yet there I was shooting sports—indoors. Fortunately, it was a well-lit arena. With my Nikon D3X and Nikkor 200–400mm lens mounted on a monopod, and with my ISO set to 1600, I switched the camera to Shutter Priority, chose a shutter speed of 1/500 sec., and fired away—trying, of course, to anticipate the next takedown.

This endeavor was made more challenging by the D3X's slow burst rate. When shooting in raw format, the camera can shoot successive frames about as fast as a tortoise crossing the street. As great as the camera is overall, it was not the right choice for shooting fast-moving sports. Still, all things considered, I'm happy that I captured this action shot.

200–400mm lens, f/6.3 for 1/500 sec., ISO 1600

HOW TO IMPLY MOTION WITH SLOW SHUTTER SPEEDS

The Challenge

When the camera remains stationary—usually on a firm support, such as a tripod—and there are moving subjects inside the composition, you have an excellent opportunity to imply motion. The resulting image shows the moving subject as a blur, while stationary objects remain in sharp detail.

Your options for motion-filled images are many: waterfalls, streams, crashing surf, planes, trains, automobiles, pedestrians, joggers—the list goes on. Some of the not-so-obvious motion-filled opportunities include a hammer striking a nail, toast popping out of the toaster, hands knitting a sweater, coffee being poured from the pot, a ceiling fan, a merry-go-round, a teeter-totter, a dog shaking itself dry after a dip in the lake, wind blowing long hair, even the wind whistling through a field of wildflowers.

Choosing the right shutter speed for a motion-filled image is often a matter of trial and error. This can be frustrating, especially if the motion you're photographing is not repetitive. There are also challenges associated with your shutter speed choice. If you opt for a too-slow shutter speed, you risk overexposing your image. A quicker shutter speed could mean a better-exposed image but a lack of fluid motion in your subject.

The Solution

Here are some general guidelines to follow when creating motion-filled images. These should provide a good starting point when you're setting up your shot.

- A 1/2-sec. exposure will produce a smooth, cottony look in waterfalls and streams.
- A 1/4-sec. exposure will make hands knitting a sweater appear as if they were moving at a very high rate of speed.
- A 30-mph wind moving through a stand of trees coupled with a 1-second exposure will usually render a composition of sharply focused trunks and branches, while the leaves appear wispy, fluttering, and overlapping.

In order to use these slow shutter speeds while maintaining a correct exposure, you will likely end up using the lowest ISO number and the smallest lens opening your camera offers. Essentially, you are trying to limit the amount of light hitting your sensor so that you can leave the shutter open for a longer period of time without overexposing the image. You also may need to call on a polarizing filter and/or a neutral-density filter for the same purpose; both reduce the amount of light hitting the sensor.

POLARIZING FILTERS VERSUS NEUTRAL DENSITY FILTERS

Polarizing filters can reduce your exposure by only 2 stops, while neutral density (ND) filters are available in 1- to 12-stop increments. There is also the "all-in-one" Tiffen 2- to 8-stop ND filter that changes density from 2 to 8 stops as you rotate the outer ring. Personally, I use the Tiffen a great deal, far more often than the polarizing filter when my sole aim is to slow shutter speeds.

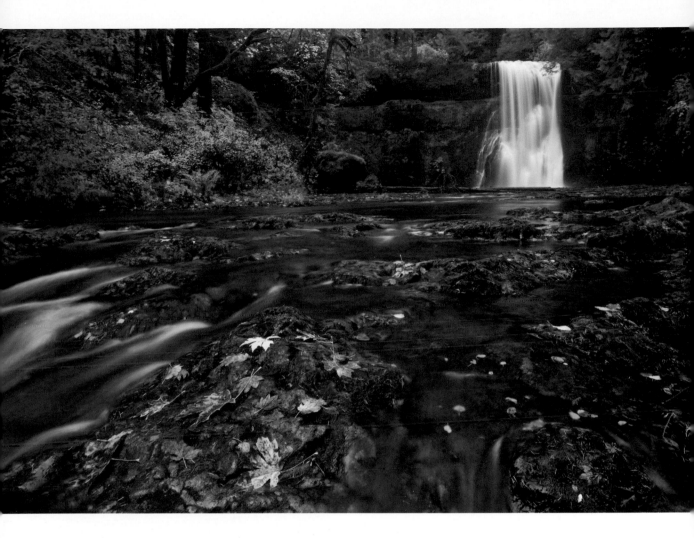

Waterfalls are great subjects for photographers first discovering the magic of slow shutter speeds. When it comes to implying smooth, cotton-candy motion of falling water, a slow shutter speed of at least 1/4 sec. is necessary.

It was a rainy, overcast day when I captured this scene, which made my life easier because I wanted to use a slow shutter speed. To limit the light hitting the sensor, and because I wanted a great depth of field, I chose an aperture of f/22 and an ISO of 100. In addition, I placed my polarizing filter on the lens to reduce, if not eliminate, the gray glare from the dull sky overhead. Without the filter, that glare would have reflected off the wet leaves and rocks (see also How to Reduce Glare on Sunny and Cloudy Days, page 40). I then adjusted my shutter speed until 1/2 sec. indicated a correct exposure.

12–24mm lens, f/22 for 1/2 sec. with polarizing filter

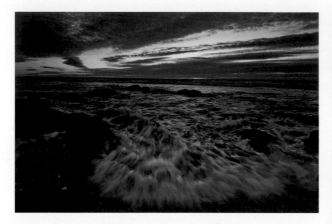

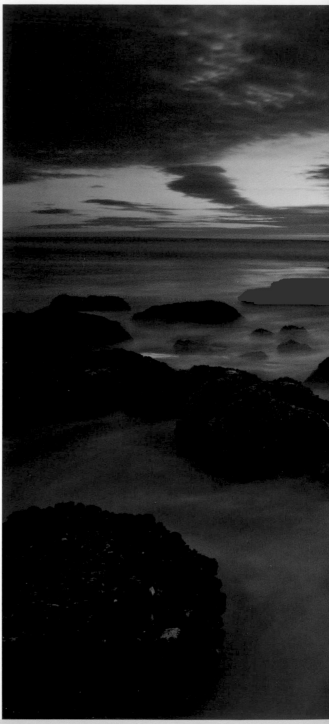

Fortunately, a low tide along Oregon's beautiful coastline, near Lincoln City, coincided with this sunset. I had no trouble finding some exposed rocks to climb on top of for an elevated position. I wanted to convey the energy of the incoming surf. The only way to do that was by selecting the right shutter speed.

With my camera and 12–24mm lens mounted to a tripod, I selected a shutter speed of 1/15 sec., slow enough to render the wave as a subtle blur, and adjusted my aperture until f/8 indicated a correct exposure. Then I played the waiting game, watching for a wave that had enough energy to flow into the entire frame, top to bottom. Within a couple of minutes, I saw my wave and captured it in the first image (above).

A few seconds later, I shifted gears, choosing now to convey the mighty ocean as a calm and tranquil landscape. With the aid of my Tiffen variable 2- to 8-stop ND filter set at a 5-stop reduction, I then decreased my aperture to f/22. This gave me a total of 8 stops of reduced light, and if we do the math, it is no surprise that I ended up with a 15-second exposure (1/8 sec. to 1/4 sec. to 1/2 sec. to 1 second to 2 seconds to 4 seconds to 8 seconds and finally to 15 seconds). Clearly, the message of this second image (right) is radically altered, from "a force to be reckoned with" to something far more docile. Both images are effective, but by deliberately manipulating the shutter speed (and using an ND filter), I changed the feel of the composition completely.

Above: 12–24mm lens, f/8 for 1/15 sec.; Right: 12–24mm lens, f/22 for 15 seconds with 2- to 8-stop ND filter set to 5-stop reduction

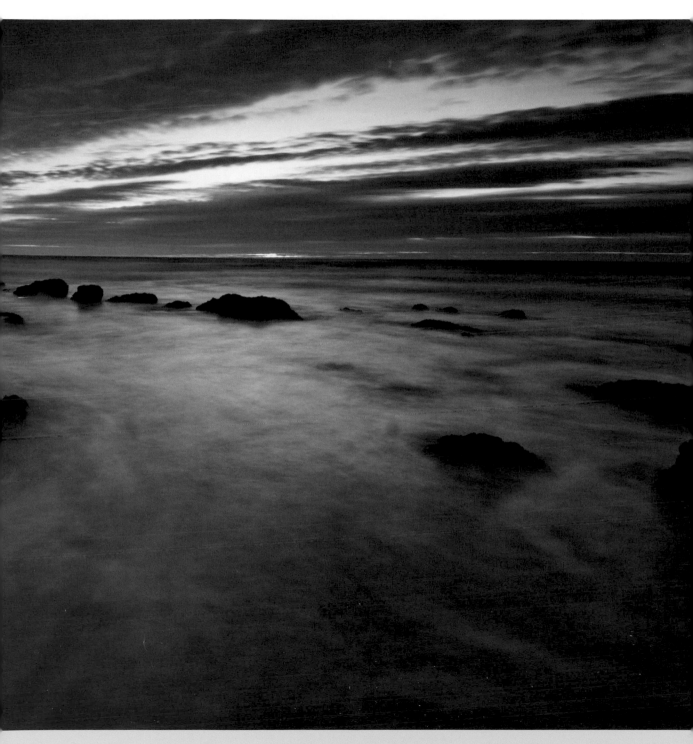

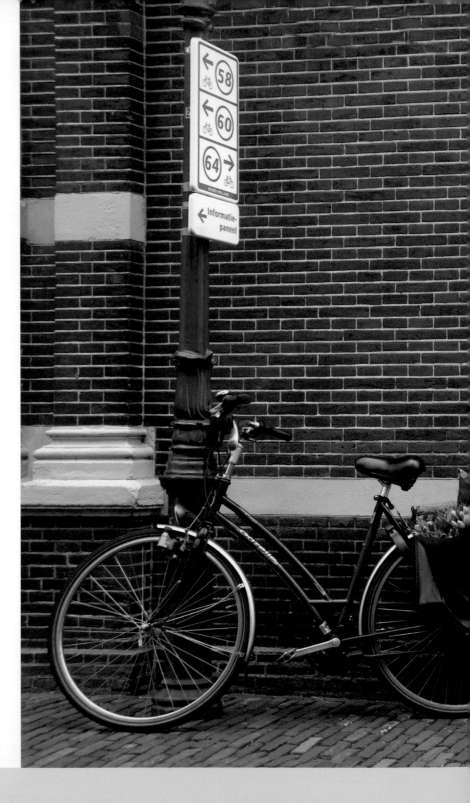

During a break in a Holland workshop, I found myself on a small street corner photographing a bicycle with flowers in its rear pouch. As much as I enjoyed framing the bike against the brick wall, it didn't offer the emotion or energy I was seeking. I stepped back to include a larger area, with the occasional biker passing through. By choosing a slow shutter speed of 1/15 sec., I ensured that the bicyclist in the foreground was a definable blur, adding energy to an otherwise calm and tranquil scene.

24–85mm lens, f/22 for 1/15 sec.

HOW TO CAPTURE MOVING TRAFFIC IN LOW LIGHT

The Challenge

Capturing cityscapes and landscapes in low light with those long, blurred light trails from passing cars may seem tricky. After all, you're dealing with dim light, long exposures, and moving subjects, not to mention a narrow window of ideal shooting times that varies throughout the year. There's also the issue of where to meter to achieve the best exposure for the ambient light in the scene, as well as the best time of day and even time of year. If the combination of exposure, composition, and timing isn't right, the scene will look more like a simple traffic shot with some blurry cars, rather than a dramatic image of light in motion.

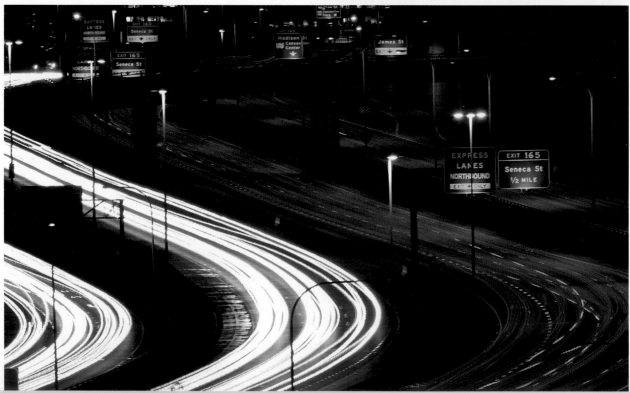

The Solution

Shooting moving traffic against the backdrop of a city skyline is a simple exposure as long as you have a tripod. The highly sensitive light meters in today's cameras make the job of establishing a correct exposure easy, even in very dim light. You just need to know where to take your meter reading. In my many years of making these images, the correct option is almost always the sky.

Here is how to capture stunning images of moving traffic in low light:

- Attach your camera to a sturdy tripod.
- Meter off of the sky, and then recompose to find your ideal composition.
- The speed and volume of the traffic will dictate shutter speed, but you'll want a minimum of 2 seconds to blur out the individual cars and create the long light trails from their headlights and taillights. If necessary, lower your ISO to force the slower shutter speed.
- If you want great storytelling depth of field, use a wide-angle lens set to f/16 or f/22.
- If sky will be part of your composition, stage your shoot during the dusky blue period just after sundown, before the sky fades to black, or just after sunrise, while the morning light is still a warm glow.
- If the sky will not be part of the composition, you can shoot at any time of night. Just remember that the best traffic for this type of image occurs during the morning and evening commutes.

THE BEST TIMES TO SHOOT MOVING TRAFFIC

The best traffic shots take place when the traffic flow is at its peak (typically Monday through Friday during the morning and evening commutes) and when there is soft light from a dawn or dusk sky to provide nice contrast. The time of year also plays an important role. The odds of combining a dawn or dusk sky with heavy traffic flows increases substantially during the late fall, winter, and early spring, because the sunrise and sunset times are closer to the heaviest commuting times. Plus, most of a city's skyline will still be well lit during those times since they are closer to actual work hours. These realities explain why the weekend photographer often comes up empty when trying for moving traffic shots with city skylines, since the interior office lights of the city skylines are often turned off and there is seldom a rush hour on Saturdays and Sundays.

When shooting this simple composition of an S-curve on Interstate 5 approaching downtown Seattle, I saw six possible options for recording a correct exposure, the two most extreme shown here. In terms of their quantitative value, both images are exactly the same exposure. However, they are vastly different in terms of their creative exposure, particularly as it relates to the emphasis on motion. It has and will always be my goal to present motion-filled opportunities in the most motion-filled way. More often than not, when there is motion in a scene, the longer the exposure time, the greater the conveyance of motion. The first image (opposite, top) was shot at f/4 for 1/2 sec. For the second image (opposite, bottom), I used f/16 for 8 seconds. Just so there is no confusion, this is not bracketing, since both exposures are the same in terms of their quantitative value.

An exercise such as this is truly eye-opening. The next time you head out the door to shoot city lights at dusk, don't hesitate to use slower shutter speeds. As this example shows, the slower shutter speed exposure had the best effect.

Opposite, top: 200–400mm lens at 400mm, f/4 for 1/2 sec., ISO 100, white balance set to cloudy; Opposite, bottom: 200–400mm lens at 400mm, f/16 for 8 seconds, ISO 100, white balance set to cloudy

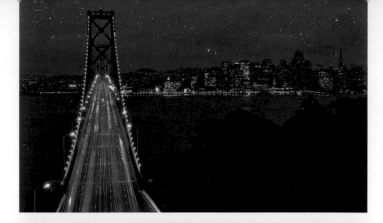

From atop the steep incline on Treasure Island, a truly magnificent view of the Bay Bridge in San Francisco awaits. With my camera and 70–200mm lens mounted on a tripod, I set the ISO to 100 (to force a slow shutter speed) and chose an aperture of f/11. Metering off the dusky blue sky to the right of the bridge, I adjusted my shutter speed until 4 seconds indicated a correct exposure. Then I returned to the composition you see in the first image (top) and fired away. At this slow shutter speed, I recorded the slow but steady flow of traffic.

As idyllic as this scene is, however, there was another dynamic image to be made, an image that exhibits an ideal combination of motion, lines, and color. After switching my 70–200mm lens for my 200-400mm lens, I kept the same exposure and composed this vertical composition of just the bridge (bottom).

On your next outing, take a closer look and see if you have another photographic opportunity to shoot. You might discover that you have been picking up your tripod and moving on to the next great shot a bit too prematurely.

Top: 70–200mm lens, f/11 for 4 seconds; Bottom: 200–400mm lens, f/11 for 4 seconds

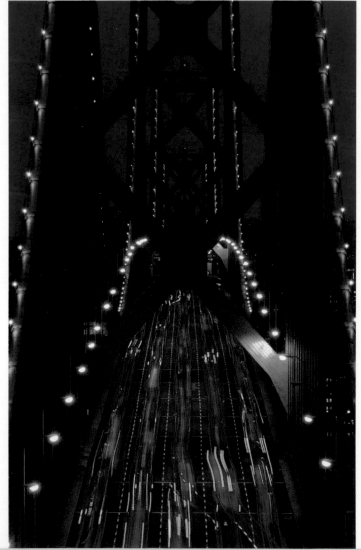

From Place de la Concorde in Paris, one can look straight up the Champs-Elysées at the distant Arc de Triomphe. Within that precious 20 minutes of dusky blue sky, and with the aid of a telephoto zoom lens, one can "stack" the constant traffic that runs up and down the Champs-Elysées. With the emphasis on creating a motion-filled landscape, I chose an ISO of 100 and an aperture of f/22 to force the slowest shutter speed. With my Nikon D3X and 70–300mm lens firmly mounted on a tripod, I aimed the camera at the dusky blue sky above and adjusted my shutter speed until 8 seconds indicated a correct exposure. I then recomposed the shot and, with the camera's self-timer set to a 2-second delay, pressed the shutter release.

70–300mm lens, f/22 for 8 seconds

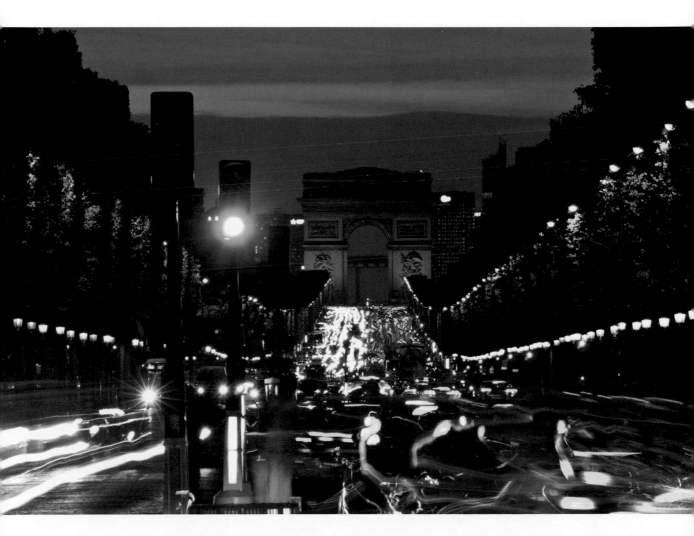

HOW TO CAPTURE MOTION BY MOVING THE CAMERA WITH THE SUBJECT

The Challenge

There are a number of ways to capture movement and convey e-motion. If your subject is in motion and you want to convey that motion with a blurred background while keeping your subject sharp, one method is to put your camera in motion relative to the subject. Moving a camera with a subject can be tricky; if you move the camera at a different rate than the subject, you will end up with a blurry image.

The Solution

To move your camera relative to the subject, you can attach your camera to the subject itself or to an object moving in tandem with the subject. Doing either of these in combination with a longer shutter speed (usually 1/4 or 1/2 sec.) will help you create an exposure in which the subject remains sharp while the background blurs with the motion of your camera. As long as your camera moves in absolute lockstep with the subject, it should record clearly and crisply, just as if you were photographing a stationary object lying on the ground.

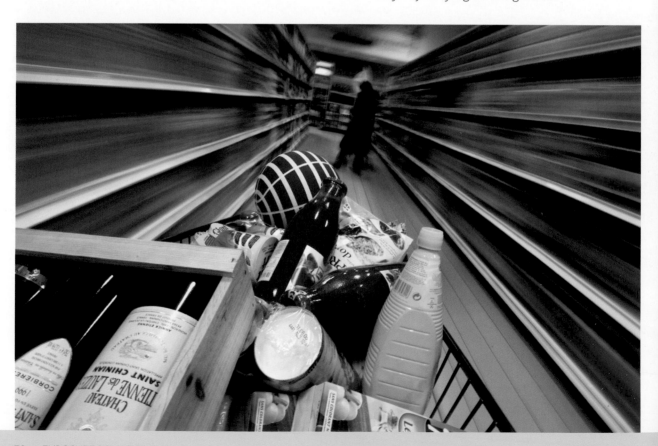

Not so for the background, however. As you move your camera during a longer exposure, the background blurs. You can see this effect by simply setting your camera to a shutter speed of 1/4 or 1/2 sec. and panning it across a scene during the exposure. Everything in your scene will blur from the camera being in motion relative to a stationary scene.

I have learned that 1/4 sec. is often all one needs to create motion. A faster shutter speed will freeze the action a bit more, limiting the blurring in the background. You might slow down to 1/2 sec. or 1 second, but much slower than that and you risk blurring your subject. If your subject includes animate objects, such as people, you'll need to keep those subjects as still as possible to avoid motion blur in the subject as well as the background. With a 1/4-, 1/2-, or even 1-second exposure, people can generally remain still enough to be rendered in sharp detail, while faster-moving background elements smear into a blur.

There are a variety of ways to attach your camera to your subject. The great folks at Manfrotto (formerly Bogen) make a host of wonderful attachments that allow you to put a camera just about anywhere you can imagine. One of my favorite gadgets is called the Super Clamp. When I mount a small head to the Super Clamp, I can easily affix my camera to almost anything.

Opposite: **After attaching** my camera to a shopping cart at a grocery store with Manfrotto's Super Clamp, I pushed the cart through the aisles, nonchalantly tripping the shutter with my cable release as I walked. With my camera set to Aperture Priority at f/16 with an ISO of 100, the meter registered a shutter speed of 1/2 sec. for a correct exposure. Since I was shooting under fluorescent lighting, I set my white balance to fluorescent. The exposures came out perfectly, and full of e-motion. Whoever said shopping can't be fun?

12–24mm lens, f/16 for 1/2 sec.

Right: **Another opportunity** to use the Super Clamp presented itself when I found myself in my front yard with a rake in hand. I reasoned it would make the arduous task of raking leaves far more enjoyable if I could get some great images out of it. My inspiration: to photograph my rake hard at work.

After attaching my Nikon D300S camera and fish-eye lens to the handle of the rake with the Super Clamp, I set my aperture to f/22. With the camera pointing down at the ground, my meter registered 1/4 sec. for a correct exposure. As I held the rake with one hand, sweeping it across the leaf-covered lawn, I pressed the camera's shutter release with my other hand. The result: a motion-filled answer to the question, what does a lawn rake "see" as it sweeps across a lawn?

Fish-eye lens, f/22 for 1/4 sec.

It's been years since I saw the movie *Jacob's Ladder*, which starred Tim Robbins as a Vietnam vet caught between life and death. While watching that movie, an idea came to me, and more than 10 years later, I finally found the time and the tools to create it.

If you saw the movie, you may recall the ghoulish-looking characters that showed their faces in subways and cars as they sped away from an anxious and confused Tim Robbins. I wanted to re-create this idea while driving a car through a tunnel. While in Lyon, France, I used my Manfrotto Pump Cup with a ball head to mount my camera and fish-eye lens to the hood of my friend Phillipe's car (shown below). Riding in the passenger seat while Phillipe drove, my intent was to fire off a number of exposures as we passed through several long tunnels.

To record a sense of motion, I needed a slow shutter speed of at least 1/2 sec., maybe 1 second. To determine what aperture I would need to use at these speeds, I needed to take a meter reading under lighting conditions similar to what we would find inside the tunnel. Getting that meter reading actually proved rather easy. We just drove through a tunnel without the camera mounted on the car but with the sunroof open so that I could shoot down onto the hood of the car and take my meter reading. With my 17–55mm lens mounted, I set my camera to Aperture Priority at f/8 and the ISO to 100, and pointed the camera at the hood of the car for a meter reading. That reading indicated a shutter speed of 1/2 sec. for a correct exposure, or 1 second at f/11.

After this first trip through the tunnel, we exited and pulled off to the side of the road. With the bright interior dome light on inside the car, I took another reading of Phillipe's face. I discovered that at f/11 I could get a correct exposure at 1 second. Now we were all set. I chose to leave the camera in Aperture Priority mode, rather than manual, knowing that if I set the aperture to f/11, the camera would record a correct exposure somewhere in the neighborhood of 1 second, depending on the varying degrees of brightness as we drove through the tunnel.

So with camera mounted on the hood of the car and pointed at us, and with the Nikon remote receiver mounted to the camera, we were ready to begin our journey through several long tunnels, but not before donning our ghoulish masks. I wanted this to be a ghoulish dream kind of photo. As we drove through the tunnels, I fired the camera from inside the car with the Nikon remote sending unit.

After making several trips through the tunnels, we pulled over and I conducted a quick review of the images. Most of the exposures were spot on, but Phillipe and I were a bit too blurry. Clearly we needed to settle down and sit as still as possible.

Off we drove once more, into the long tunnel, wearing our masks. When we pulled over to review our images again, a car with four men in street clothes pulled up behind us, one shouting, "Get back in your car!" It took a great deal of explaining and a small degree of pleading to convince these undercover cops that we were simply taking pictures for a book project and not about to rob a bank! Even more exciting, our last run through the tunnel proved the best run of all.

In another interesting twist, the light blue car recorded with an odd bronze cast in the tunnel lighting, and no amount of Photoshop trickery could recover the original color. However, while trying to restore the light blue, I came upon this wild purple color. The more I viewed the image, the more I liked the purple, so now the car is purple! I found this color as a result of playing with both the Color Balance and Hue/Saturation controls in Photoshop.

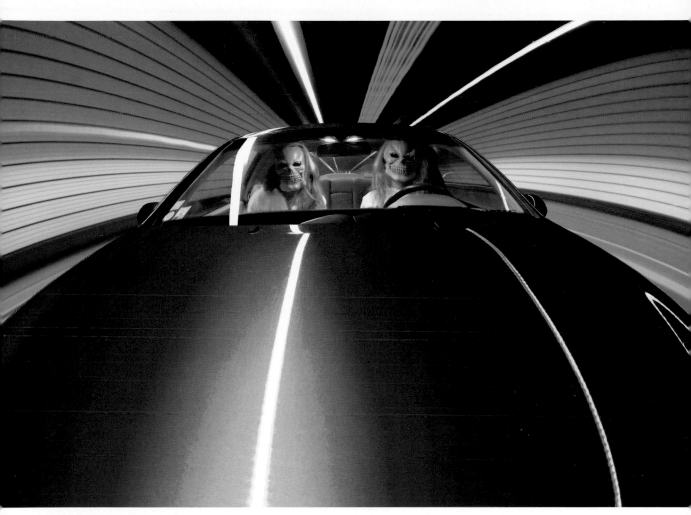

17–55mm lens, f/11 for 1 second

Ask any commercial photographer to name the most vital tool of the trade, and the answer will be duct tape. Sure enough, on this particular shoot, duct tape was king. I was shooting for a company called Flex Solutions, and they wanted to convey their speed and efficiency. With my tripod at full extension (as we can see in the first shot, top), I was able to jam the lower 18 inches of its legs between the slats of the central pallet. After wrapping the legs and portions of the pallet in duct tape, I securely mounted the camera and lens to the tripod head, and we were set to go.

As the lift truck driver drove down the product-lined aisles, I walked alongside the lift truck at a hurried pace, firing the camera with an attached cable release. I'd set the camera to Aperture Priority mode at f/22, so my exposure times varied between 1/4 sec. and 1 second (the light values varied as the lift truck ventured down different aisles, causing the different shutter speeds). The second shot you see here (middle) was one of seven that turned out well. I captured the third shot (bottom) with the camera and tripod attached the back of a different lift truck, using a similar overall setup and the same exposure setting.

Middle: 12–24mm lens, f/22 for 1/2 sec. Bottom: 14mm fish-eye lens, f/22 for 1/2 sec.

GIVE YOURSELF A HAND

Here is an idea for capturing e-motion-filled images that you can use without even leaving home. Spend an hour or a whole day shooting your hand on the move. While holding the camera with one hand, photograph your other hand at various slow shutter speeds, such as 1/15 or 1/8 sec. You will be pleasantly surprised at the results.

How about your hand opening the fridge? Getting a drink from the cooler? Serving some cake or pie? Playing air hockey? The possibilities are endless!

At the vegetable market in Lyon, France, I followed my hand as it "flew" across the table of vegetables with a 10-euro note to pay the vendor.

12–24mm lens, f/16 for 1/15 sec.

After getting my cup of coffee at a café in Christchurch, New Zealand, I followed my hand as it looked for an outdoor table to put down the coffee.

12–24mm lens, f/16 for 1/8 sec.

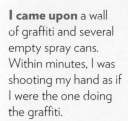

I came upon a wall of graffiti and several empty spray cans. Within minutes, I was shooting my hand as if I were the one doing the graffiti.

12–24mm lens, f/11 for 1/15 sec.

PHOTOGRAPHING AT NIGHT

There seems to be an unwritten rule that it's not possible to get good pictures before the sun comes up or after it goes down. After all, if there's no light, then why bother? Nothing could be further from the truth.

Low-light and night photography do pose special challenges, thanks to long exposures, variable light sources, and high ISO settings. You'll need a tripod, and you'll need to compensate for some bright light sources—such as lightning or a full moon—against otherwise dark settings.

However, these challenges shouldn't stop you from enjoying the wonderful photography options available at night and in low-light situations. If it's your goal to record compelling imagery—and it should be—then night and low-light photography are two areas where compelling imagery abounds. Don't let the challenges scare you away!

HOW TO PHOTOGRAPH A FULL MOON

The Challenge

Metering photographs of the full moonrise can be difficult. Many photographers shy away from these images because they're unsure how to get a sharp, well-exposed photo of the bright full moon while also bringing out detail in the landscape. However, a moonrise is actually easy to expose. It's just a frontlit scene—much like those you'd encounter in daylight—only in a low-light situation.

Solution #1: Photograph the Night Before the Full Moon

Using online calendars and mobile apps, it's simple to determine when the full moon will be rising, so you can scout your scene in advance. But here's a tip: it's typically best to shoot the moonrise the night *before* the full moon. On that evening, when the moon is *almost* full, the eastern sky and the landscape below are almost the same exposure value. This makes metering and exposing much simpler. Also, an almost-full moon has a yellow cast that provides striking contrast against a dusky blue sky.

Typically, my composition will dictate where and how I set my exposure. When shooting the full moonrise as part of a larger landscape or cityscape, I first determine my aperture choice. Do I need a deep depth of field, such as f/16 or f/22? Or is everything at the same approximate focal distance, in which case f/8 or f/11 will work? With my aperture set, I point the camera toward the eastern sky, to the left or right of the rising full moon, and adjust my shutter speed until a correct exposure is indicated. Note that your shutter speed should not exceed 8 seconds. Anything longer and you will record the motion of the earth as it revolves, resulting in an egg-shaped orb in place of your moon.

As you will quickly discover, these longer shutter speeds require a firm support or tripod, unless you choose to shoot with a high ISO, such as 3200. High-ISO images used to come with a lot of digital noise, but that is no longer the case. Still, high ISOs continue to produce images that are flat in both overall color and contrast. I am sure that the day will come when we will see these higher ISOs produce amazing color and contrast, but until then, it's best to call upon the lower ISOs (and your tripod) for the best possible shot.

If, on the other hand, your goal is to shoot *only* the moon, you'll need a different set of exposure settings. The three most popular settings are: f/8 for 1/125 sec. with ISO 100, f/8 for 1/250 sec. with ISO 200, and f/8 for 1/500 sec. with ISO 400.

Solution #2: Make a Double Exposure

On many models of Nikon cameras, and on some models of Pentax and Canon cameras, you can use the camera's double-exposure feature to capture the best of both worlds at moonrise. Let's say the moon is coming up behind you, to the east, but you want to shoot the landscape or cityscape in front of you, to the west. Using double-exposure mode allows you to photograph the scenery in front of you, and then turn around and shoot the full moon behind you, composing it exactly where you want it to be in combination with the landscape that was in front of you. Press the shutter release and voilà! You now have the moon "setting" in the western sky, saving you a return trip at dawn to shoot the actual moonset.

A few times each year, the orientation of the earth and moon creates a full moonrise right over the Chicago skyline, viewable from the rooftop deck of my building. However, like all full moonrises, shots like this one are 100% weather dependent; a cloudy sky in the forecast spells doom. So it was with extra enthusiasm that I composed this shot, because the skies were clear and the setting was perfect.

I wanted this image to be all about the vast universe and the full moon. As such, I pushed the city skyline down toward the bottom third of the frame, allowing the dusky blue sky and the full moon to dominate the scene. Note the upside-down triangle formed by the lines of the city's buildings, as if the city was coveting the full moon. Since everything in the scene was at the same focal distance, I chose an aperture of f/11 and then metered off of the dusky blue above the moon, adjusting my shutter speed until 2 seconds indicated a correct exposure. I then recomposed the scene, and, with the camera on a tripod, I tripped the self-timer to record the exposure.

70–300mm lens, f/11 for 2 seconds

To do this, set your multiple-exposure setting to two exposures. (To determine if your camera has this feature, refer to "Multiple Exposure Settings" in your camera's user manual.) Now you can shoot the full moon up there in the eastern sky, surrounded by all that black, with your moderate telephoto lens at f/8 for 1/125 sec. with ISO 100. Place the moon in a portion of the frame that won't conflict with the buildings you'll capture in your second exposure. Then turn around. With your camera on a tripod, shoot your city skyline with a standard zoom lens at f/16 for 4 seconds. Presto! The camera processes both of your exposures into a single full-moon city skyline exposure. If ever there was one function on my camera that allowed me to stay true to my motto of "get it done in camera," this is it.

Solution #3: Combine Images in Photoshop

For those whose cameras don't offer the multiple-exposure feature, or who want to add a moonrise after the fact, Photoshop is always an option. You can shoot the moon against a black sky an hour or two after it rises at the simple exposure of f/8 at 1/125 sec. using ISO 100. Then add that full moon to landscapes or cityscapes in Photoshop. If you shoot the moon the night before it becomes full, when the rising moon has that appealing yellow cast, the contrast of yellow against a dusky blue sky often looks more authentic in a digital composition than a full moon shot against a black, deep-night sky.

It's imperative that the size of your full moon looks proportionate to the landscape in which you place it. If you shoot the full moon with your 105mm lens and then add it to a landscape that you shot with a similar focal length, you're probably in good shape. But if your moon was shot with a 300mm focal length lens, and your cityscape with a 24mm wide-angle lens, it's better not to pair them. The moon will appear out of proportion and ruin the realism of your image.

HOW TO EXPOSE A FULL MOON ON ITS OWN

When you want to capture an image of a full (or almost full) moon by itself against a black sky, the standard exposure is f/8 for 1/125 sec. at ISO 100, f/8 for 1/250 sec. at ISO 200, or f/8 for 1/500 sec. at ISO 400. The choice is up to you; just be careful if your ISO causes you to use a shutter speed that's lower than the maximum focal length of your lens—for example, shooting at ISO 100, f/8 for 1/125 sec. with a 70–200mm lens. If you do this, use a tripod. Handholding your camera at a shutter speed slower than the maximum focal length of your lens is seldom a good idea, even if you're using vibration reduction (VR) or image stabilization (IS). It's been my experience that VR and IS have done nothing more than give photographers reason to be careless and unstable when handholding their cameras.

To demonstrate the multiple exposure technique, I set up outside of Portland, Oregon, near the bank of the Willamette River. I first turned my attention to the eastern sky and composed a shot of the full moon with a 70–200mm lens, placing it in the upper right of the frame and setting the exposure at f/8 for 1/125 sec. at ISO 100 (top, left). Then, bracing my camera on a tripod, I turned around and composed a shot of the Portland skyline, bridge, and river in the western sky with my 28–70mm lens, exposing at f/16 for 4 seconds (top, right). My Nikon D300 processed both exposures into a single full-moon city skyline exposure (bottom).

Top left: 70–200mm lens at 80mm, f/8 for 1/125 sec.; Top right: 28–70mm lens at 50mm, f/16 for 4 seconds

HOW TO CREATE A WARMER FULL MOON IN PHOTOSHOP

When shooting a full moon against a black sky, a white moon will always be the result. However, you can always get the more familiar warm yellow-orange moon we often see rising in the eastern sky by opening the image in Photoshop and using Image > Image Adjustment > Photo Filter > Warming Filter (85) at a density of about 75%.

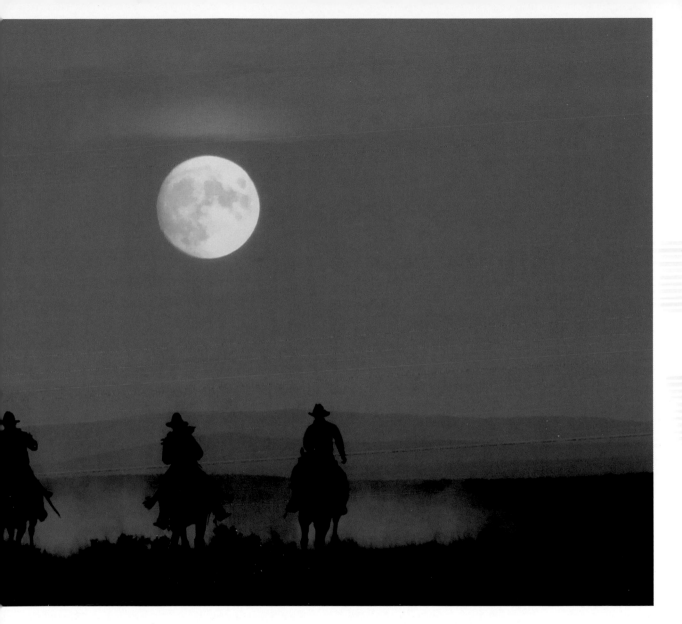

Using Photoshop, I created this image of cowboys riding under a full moon by combining a moonrise image with a backlit shot of three cowboys. I actually photographed these three real cowboys in eastern Oregon against the harsh light of a mid-afternoon sky, intentionally underexposing the image to give it a late-day, low-light appearance. To do that, I fixed my camera and 200–400mm lens on a tripod, set the camera to Aperture Priority mode at f/11, and made the underexposure. Then in Photoshop I combined the image with one I'd made three months earlier in Arizona of a yellowish full moon against a dusky blue sky. The combination of the two images shown at left resulted in the single exposure you see above.

Opposite, top: 200–400mm lens, f/11 for 1/1000 sec.; Opposite, bottom: 200–400mm lens, f/8 for 1/125 sec.

HOW TO PHOTOGRAPH LIGHTNING

The Challenge

Shooting a lightning storm is anything but predictable. As far as I am concerned, any shot of lightning is commendable, as it takes not only patience but a helping hand from Lady Luck. But while Lady Luck plays a big role, there are things we can do to increase our chances of a good exposure.

Many photographers wonder how fast of a shutter speed they should use to record images of lightning. Lightning strikes faster than the blink of an eye, so how can one possibly time the exposure, much less aim and compose the shot, in that tiny splinter of time?

The Solution

Believe it or not, a fast shutter speed rarely works. In fact, the *longer* or *slower* your shutter speed, the better the odds of creating these dramatic exposures. Here are a few fundamentals of photographing lightning:

- Recording a correct exposure of lightning is much like recording a correct exposure of the burst of light from your portable electronic flash: they are both 100% dependent on the correct aperture. In the case of lightning, try an aperture of f/11 with ISO 100 or 200, or f/16 with ISO 400 or 640.

- A tripod is absolutely essential since most lightning strikes take place in low light, which necessitates a slow shutter speed.

- You should call upon a 2- to 6-stop variable ND filter or at least a polarizing filter, since the reduced light allowed through to the lens by these filters will force your exposure time to be much slower. The longer your shutter stays open, the better your odds of capturing lightning.

If, for example, you shoot a city skyline at dusk during a lightning storm, the odds are good that your camera's light meter will indicate a correct exposure near f/11 for 2 seconds at ISO 200. If you now add a 2- to 6-stop variable ND filter and rotate it until it reduces 4 stops of light, your correct exposure will be f/11 for 30 seconds. Instead of having to press the shutter every 2 seconds (and potentially miss a lightning strike), your shutter will stay open for a full 30 seconds for a correct exposure. During this 30-second period, you increase the odds of recording not just one but several lightning strikes.

So why not just stop down the lens from f/11 to f/22, or possibly f/32, to force a slower shutter speed? The reason this will not work is that capturing good lightning shots is aperture-dependent. Most lightning strikes look perfectly exposed through an aperture of f/11 when using ISO 100 or 200. When you shoot lightning at f/22 or f/32 at ISO 100 or 200, however, the lightning usually looks too dark.

Personally, I prefer lightning storms that take place right around dusk or dawn, when there is some light on the landscape. Experience has taught me that I need at least an 8-second exposure—even longer if possible, maybe 15 or 30 seconds. Sometimes you will need to call upon your 2- to 8-stop ND filter to turn a sky brightened by a lightning bolt back into a darkened night sky.

Let's assume that to expose a city skyline near dusk, I meter off the dusky blue sky and get an exposure of f/11 at 1/8 sec. If I now place my 2- to 6-stop ND filter on the front of my lens and rotate it so that I'm employing the full 6 stops, then I would have to increase my exposure time by 6 stops to return to a correct exposure. And what is my new exposure time? From f/11 at 1/8 sec. we count down 6 stops, going from 1/8 to 1/4 to 1/2 to 1 to 2 to 4 to 8 seconds. My reason for choosing at least an 8-second exposure is simple: I hope that one or two lightning bolts will strike somewhere in the overall composition of this

cityscape during that long exposure. I am simply using the longer exposure time to increase my odds of recording a lightning strike or two.

You certainly don't need 8 seconds to record an exposure of lightning, by the way. Lightning bolts travel from cloud to ground at speeds up to 93,000 miles per second. The actual flash of lightning lasts for about 1/2000 sec. Now you see it, now you don't!

COMBINING MULTIPLE LIGHTNING STRIKES IN PHOTOSHOP

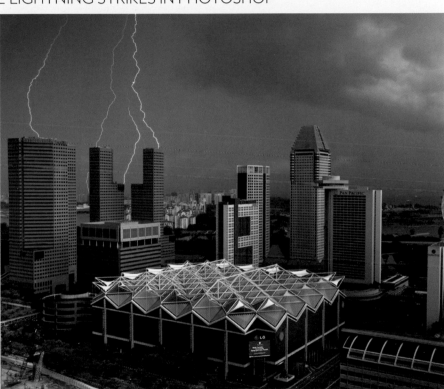

Although I am not a fan of manipulating images in Photoshop, I can be persuaded to do this technique with the understanding that it is a trick. The trick is combining a number of lightning strikes into a single exposure.

Keep in mind that this will work only when the camera and lens are on a tripod. You must also use the same focal length and composition over the course of your exposures. As you can see, I captured all three of the exposures along the left-hand side from the same location with the same focal length lens. In two of the shots, you can see a lightning strike, and in the third image, the large jumbotron screen is visible with a red screen. Because all three images line up exactly, I was able to place the images atop one another in Photoshop. Using several layer masks, I "painted" in the important areas, so I ended up with an image that is realistic but very much manipulated.

All images on left: 24–85mm lens, f/11 for 15 seconds with 2- to 8-stop variable ND filter

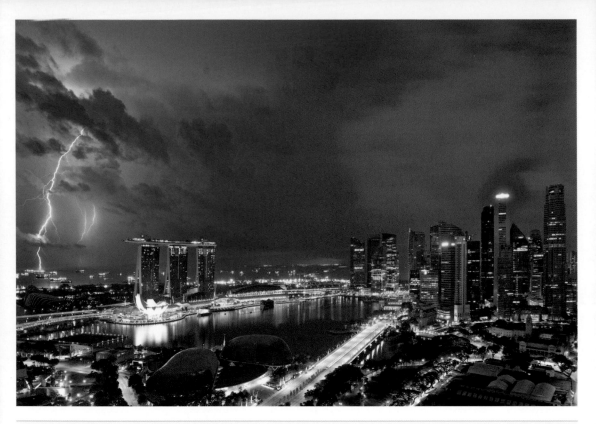

STAYING SAFE UNDER ELECTRIC SKIES

When you're out shooting lightning, please keep in mind these safety tips, compliments of the good folks at the Kansas State University Research Extension.

- Listen to the weather and heed warnings. The National Weather Service offers this rule: When lightning is seen, count the seconds until thunder is heard. If it is 30 seconds or less, seek shelter and stay there until 30 minutes after you hear the last rumble of thunder.

- When seeking shelter, do so in a substantial building or enclosed metal vehicle. Avoid open metal buildings or canopies, such as a picnic shelter, that may attract lightning.

- If you are outdoors, avoid water, open fields, and high ground, as well as metal objects, such as power tools or farm machinery.

- If lightning is striking nearby, crouch down. Place your feet together and your hands over your ears to minimize the noise from the thunder.

- If you are inside, unplug appliances. Minimize use of the telephone (which can transmit an electrical charge), and wait to take a shower or bath until the storm has passed.

- If you are trying to assist someone who has been struck by lightning, check to see if he or she is breathing, administer CPR, and ask someone to call 911. People who are struck by lightning do not carry an electrical charge. The charge can, however, damage or destroy internal organs and cause death.

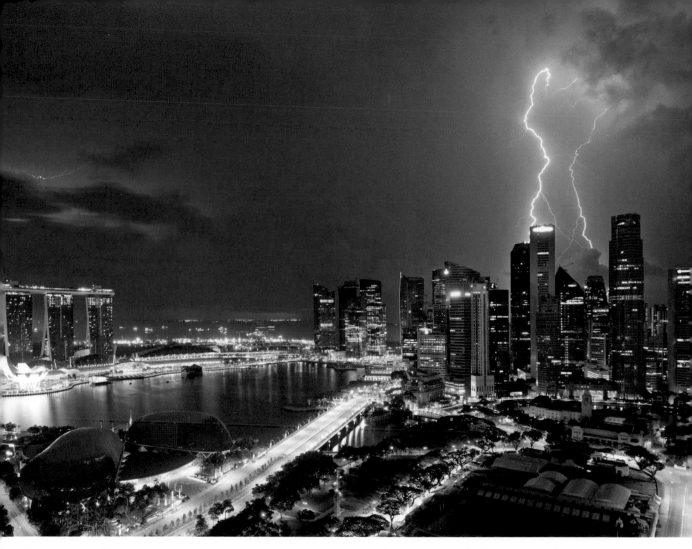

From my 41st-floor hotel room in Singapore, I was awakened at three a.m. by a loud crack of thunder. Had I closed the sliding glass door to my outside deck before bed, I might have only stirred and fallen back asleep. But as it was wide open, the thunder woke me completely and spurred me to my deck.

I set my camera for 15-second exposures at f/11, with a white balance set to tungsten/incandescent to accommodate the color temperature of the city. Within an hour, I had witnessed more than a hundred lightning strikes and had captured more than a dozen shots similar to the first one shown here (opposite). I was happy with these images, despite the fact that the bulk of the lightning strikes were

taking place to the far left. Compositionally, this was not ideal. I was determined to include the Singapore skyline in my frame as well as the Marina Bay Sands casino and hotel on the left. So I kept shooting, hoping for the mother lode, a lightning strike hitting right atop one of the city's skyscrapers.

Somewhere around five a.m. my persistence paid off. No lightning strike that night was more impressive than the one you see above. It may have taken me more than 35 years of shooting, but I have finally recorded an *awesome* lightning strike!

Both images: 16–35mm lens at 18mm, f/11 for 15 seconds, white balance set to tungsten/incandescent

HOW TO PHOTOGRAPH FIREWORKS

The Challenge

Photographing fireworks poses many of the same challenges as photographing lightning. You're shooting at night with long exposures, balancing pops of bright light against the exposure value of a darkened landscape. You're also dealing with a brief display of light that glimmers and is gone, so it's important to time your shots correctly to maximize the impact of the firework explosion.

The Solution

To photograph fireworks, you need a tripod, a slow shutter speed (often 2–4 seconds), and an aperture of around f/8 to f/11. You may need to choose a low ISO, such as 200, to force the slower shutter speed. It's also important to set up your composition in the anticipated area of the firework burst. Happily, unlike lightning, fireworks are far more predictable, especially when it comes to the location of the explosion. Fireworks displays usually take place in designated areas, allowing you to set up your camera with a given point of view. Trigger your exposure after you hear that familiar *thump*, before the firework erupts into a brilliant light display.

One of the biggest keys to successfully photographing fireworks is getting a good spot. I have been very lucky with some of my shooting locations, including a perfectly placed apartment in Lyon, France, and rooftop access in Doha, Qatar. Without this sort of prime photo real estate at your disposal, it's critical to arrive early and stake your claim to your preferred shooting spot before someone else beats you to it.

HAVING FUN WITH FIREWORKS

Much to my chagrin, most fireworks displays take place only after the sky has turned black. If I were running the show, I would insist, to the joy of photographers everywhere I am sure, that the fireworks start about 15 minutes after sunset as the sky begins to turn that wonderful dusky blue color. The contrast of all those bright red, yellow, orange, and pink fireworks explosions against a dusky blue sky would be so much more compelling, but, as the saying goes, when life gives you lemons, make lemonade. So here is an idea that I have had for some time but have yet to try. Using a moderate wide-angle lens and with your camera and lens on a tripod, choose a somewhat low position, 2 to 3 feet from the ground, with the camera pointed up to the sky where the fireworks will take place. Have some family members at the ready. Place your flash on the hot shoe (or use the built-in flash) and set it for Second Curtain Sync or Rear Curtain Sync. You are about to shoot a 2- or 4-second exposure with your aperture set to f/11 based on an ISO of 200. Turn on your flash, put it in manual mode, and make a note of the flash-to-subject distance indicated for a correct exposure. Now direct your family members to move to that distance from the flash, and after pressing the shutter release, tell them to jump high with elation near the end of the 2- or 4-second exposure time (this may take a few attempts). The result will be a great image of your family jumping with joy against a background of fireworks!

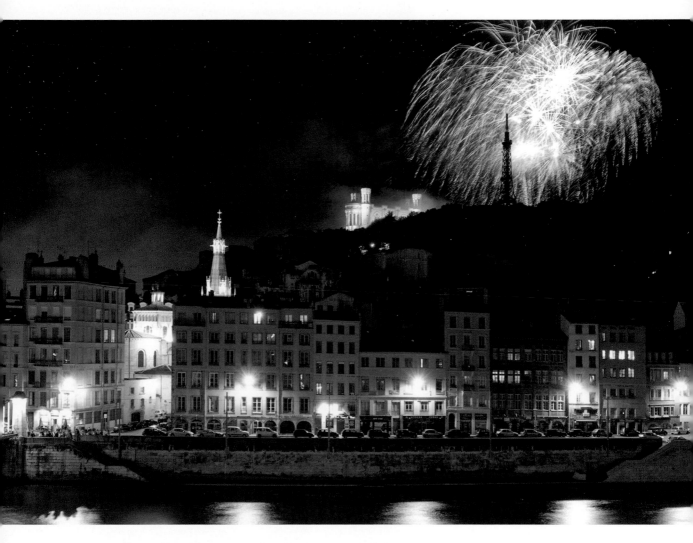

The Fête des Lumières (Festival of Lights) takes place during the first weekend of every December in Lyon, France, and fireworks are an integral part of this four-day event. From the very comfortable and cozy confines of my terrace in downtown Lyon, I had a wonderful view of the fireworks exploding over Old Lyon. With my camera and 24–85mm lens mounted on a tripod, my aperture set to f/11, and my ISO at 200, I determined a shutter speed of 2 seconds. I watched and listened to the rockets shooting into the night sky, determining the approximate time it took each one to reach its zenith and explode into a sparkling array of light. As each rocket hurtled upward, I would time my exposure to begin just before the big blast, tripping the shutter with my cable release. During the 2-second exposure, my camera recorded the motion of that bright and colorful burst.

24–85mm lens, f/11 for 2 seconds

Atop the headquarters of the telephone company in Doha, Qatar, eight students and I waited with great anticipation for the fireworks show in celebration of Qatar's National Day. With our cameras mounted on tripods and our exposures set to f/8 for 4 seconds with an ISO of 200, we were ready. Before long, we were "oohing" and "aahing" at the perfect exposures displayed on our camera screens.

24–85mm lens, f/8 for 4 seconds

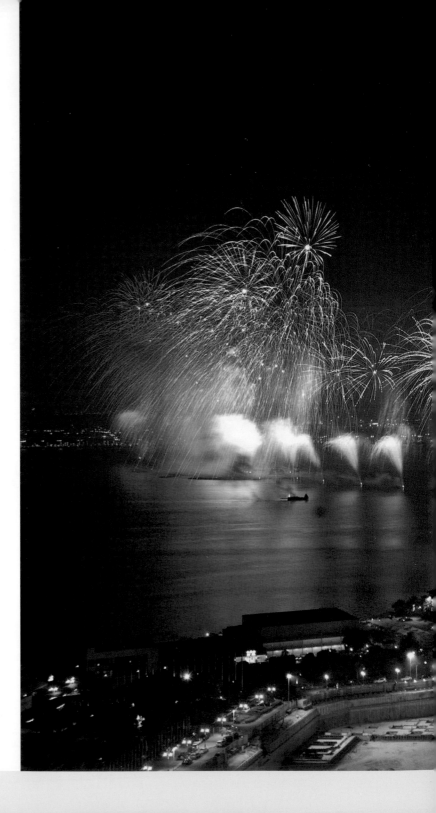

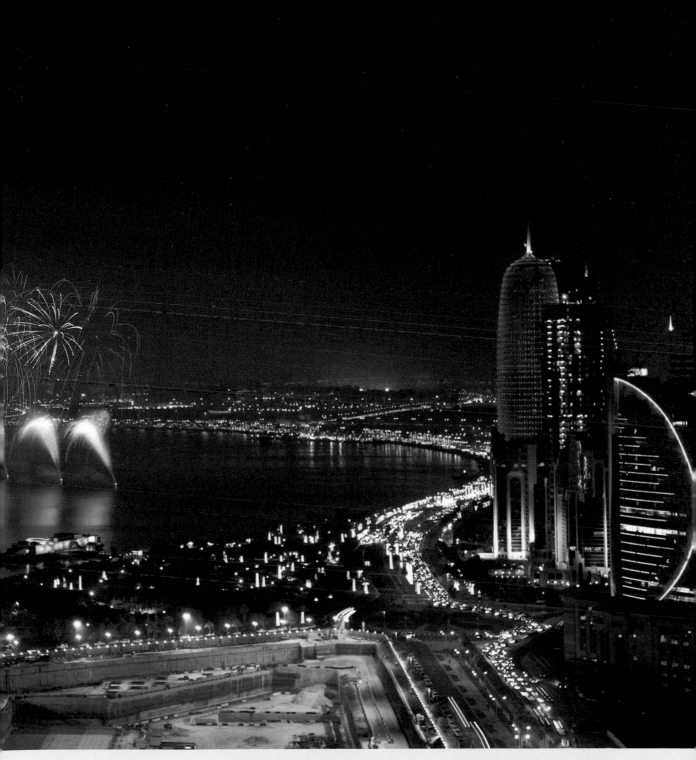

USING FLASH AND REFLECTORS TO MODIFY AMBIENT LIGHT

Sooner or later, every photographer runs into the challenge of mixing different light sources in a single exposure, especially when working with electronic flash and ambient light. The flash has one exposure value; the ambient light has another.

But combining ambient and flash exposures isn't as difficult as it seems. The key is to meter off the right part of the composition. Also, it is vitally important that your camera is metering in manual exposure mode and not Aperture Priority, Shutter Priority, or Program mode. You want *full control* over how much or how little of that ambient light is exposed, and only manual exposure can do that. Yes, I know it can be done when in Aperture or Shutter Priority modes if you use your autoexposure overrides, but those can get complicated, and you'll have big problems if you forget to reset the autoexposure overrides to zero once you move on to another location. Just use manual exposure and your worries will be over.

HOW TO EXPOSE A BACKLIT PORTRAIT

The Challenge

Shooting backlit portraits can give photographers fits. Balancing a strong backlight with the darker exposure of your subject's face may seem daunting, especially if the bright backlight produces a pronounced rim light around your subject's hair. While this can add a pleasing effect, as you frame a backlit portrait there is a danger of the light meter being fooled by excessively bright rim light around the hair, which can cause a false meter reading. This situation makes it tough to properly meter and expose the front part of your subject.

The Solution

Shooting backlit portraits can produce powerful, e-motion-filled imagery *if* you know when to take them, where to take your meter reading, and how to use a reflector for supplemental light.

When to take backlit portraits? Shoot them when the sun is at a low angle in the sky, in early morning or late afternoon. Where to take your meter reading? Move in close and fill the frame with the subject's face; then adjust your light meter until a correct exposure is indicated.

And last, it can be useful to use a reflector when shooting backlit subjects, particularly people. A reflector is a circular piece of highly reflective fabric stretched tightly over a collapsible metal ring. The fabric is usually shiny gold, shiny silver, or a sheer white material. Typical sizes range from 12 inches in diameter up to 3 feet. When you point a reflector toward your light source (the sun, in most outdoor portrait scenarios), it acts likes a dull mirror, reflecting much of the light onto whatever you point it toward.

If you have someone with you who can serve as your photo assistant, ask him or her to hold the reflector for you. Then you can concentrate on the overall composition as well as direct the placement of the reflected light. If there's no one else around, simply ask your subject to hold the reflector. I have done this countless times, and it actually serves as a great answer to the most often asked question from portrait subjects: "What should I do with my hands?"

When using a reflector and once you see the light bouncing from your reflector onto your subject, take your meter reading off the subject's face and set your exposure; then recompose and shoot.

Photographing my wife, Kate, in strong backlight, I set my camera to Aperture Priority mode with my aperture at f/5.6. When I metered off of her face and the meter was confronted with the bright backlight surrounding her, it produced an exposure time of 1/500 sec. As you can see in the first example (opposite, top left), this exposure was fine for the backlight but underexposed the face by about 2 stops.

To fix this, my wife held an 18-inch reflector with its gold foil side facing the western sky and setting sun, bouncing gold light onto her face. With my camera still set to the original exposure of f/5.6 for 1/500 sec., I shot an additional exposure. As you can see in the final image (opposite, bottom), the added fill light from the reflector has now made the exposure for the face correct.

Granted, since I was shooting in raw mode I could have added 2 stops of light to the face in postprocessing instead of using the reflector. I would have made a layer mask in Photoshop and "painted" the 2-stop increase of exposure over her face and hair, being careful not to paint over the already overexposed backlit edges of her hair. It would have taken me at least 10 minutes to do this, however, so why not just get the exposure right in camera and save the trouble?

Both images: 105mm lens, f/5.6 for 1/500 sec.

A QUICK GUIDE TO USING YOUR OFF-CAMERA FLASH

There are two methods to using your flash: Manual and auto, better known as TTL. When using manual flash exposure with a Vivitar 283, Nikon SB-800 Speedlight, Nikon SB-900, Nikon SB-910, or the Canon Speedlite 580EX II with the custom function 5-3 in place, start by inputting your aperture setting on the back of your flash unit. Also, set the zoom of the flash head to the lens focal length you plan to use for the composition. The five flashes listed above will then tell you the correct flash-to-subject distance for your exposure. This is the distance the *flash* should be from the subject you want to illuminate, *not* the distance between your camera and that subject.

A correct flash exposure (for the foreground) is based on using the right flash-to-subject distance for whatever aperture you're using. But since normally we want to mix flash with whatever ambient light exists in the scene, such as a sunset sky in the background, we also need to correctly expose for that ambient light, and this is done via shutter speed. To determine your shutter speed, simply meter as you would without the flash, adjusting your shutter speed until a correct exposure is indicated.

With your camera set to the correct aperture and shutter speed, and your flash set to the same aperture and indicating a correct flash-to-subject distance, simply make sure the flash is that distance from the subject and fire.

If you are not using one of the above flashes, or if you just don't "get" manual flash, set your flash to the TTL setting. Tell the flash what aperture you will be using and the TTL function will then indicate a range. For example, 3 to 12 feet. This simply means that the foreground subject you wish to illuminate must be within 3 to 12 feet of your flash for a good flash exposure.

If your flash needs to be in a different location than your camera to maintain the correct flash-to-subject distance, you may need a remote trigger, like a PocketWizard, or a sync cord, so you can fire the flash from a different spot.

When I initially shot this backlit sunflower, I recorded an acceptable exposure of the yellow petals because they are translucent. However, note the dark center of the flower in the image below. Since it isn't translucent, it requires a much longer exposure time than the petals. The solution in this case was to place some fill light on the center of the flower with a reflector. I held up my gold reflector to bounce some sunlight back onto the dark center area. Presto! The difference is clear.

Both images: 80–200mm lens, f/8 for 1/200 sec.

HOW TO EXPOSE A SUBJECT IN SHADE AGAINST A BRIGHTLY LIT BACKGROUND

The Challenge

One common and tricky exposure situation is photographing a subject in open shade with a more brightly lit background. If you expose for the darker subject, the image is overexposed. If you expose for the brighter background, the subject is underexposed. The resulting image is either dark overall or very dark in the foreground, with a subject that fades into a black silhouette against the brighter background.

The Solution

The solution for these situations is a combination of fill flash and exposure adjustments.

Every subject, flashed or not flashed, requires the correct aperture and shutter speed if you hope to record a correct exposure. For an ambient exposure, the camera's light meter indicates the correct aperture and shutter speed based on the ambient light in the overall scene. A flash exposure, on the other hand, depends on the right flash-to-subject distance, which is determined solely by your aperture. The smaller the aperture, the closer your flash needs to be to the subject. When you plug your chosen aperture into your flash unit, it will tell you the correct flash-to-subject distance. Then simply position your flash that distance from the subject.

If you want to adjust the brightness of the background,

on the other hand, which is the same as the ambient exposure, you adjust your shutter speed. Keeping the aperture the same, you can render the background lighter by lengthening your shutter speed, or darker by shortening your shutter speed. Just make sure your shutter speed is in sync with the flash. Put in simpler terms, don't use anything faster than 1/200 sec. with some cameras or 1/250 sec. with others (refer to your camera's manual to know which shutter speed is your fastest sync flash speed).

Confused? Try thinking of a flash-ambient exposure this way: when you use flash, you have two light sources, the ambient light and the supplemental light from your flash. Shutter speed controls the ambient light, while aperture controls the flash exposure. In other words, shutter speed determines the length of time the ambient light hits the digital sensor (or film), while aperture

After finishing a morning lecture at the Kitara Cultural Village in Doha, Qatar, several students and I decided to walk to a nearby coffee shop. On our way back, we came upon a large patiolike area over which large pieces of canvas were draped, providing a buffer from the blazing sun. I was struck by the potential for a graphic composition; luckily, one of the students became a willing subject.

A shot like this requires several exposure calculations to be successful. The first was to determine the correct ambient exposure for the canvas and blue sky. With my subject in place, I framed him against the canvas and sky from a low kneeling position while shooting up. With my aperture at f/11, I adjusted the shutter speed until 1/200 sec. indicated a correct exposure. As you can see from the image on the left, the canvas and sky look great but the subject is rendered as a silhouette because he is not as brightly illuminated.

With my Nikon SB-900 flash at the ready, I dialed in an aperture of f/11 on the back of the flash; the distance scale then told me I needed a flash-to-subject distance of 9 feet for a correct flash exposure. Since the subject was only about 5 feet away, I powered the flash down from 1/1 to 1/2 power. The flash's distance scale now gave me a 5-foot flash-to-subject distance, which proved the correct flash exposure (above). So, as this image illustrates, start by setting your exposure for the ambient light. Then follow with your flash, setting the same aperture and then simply holding your flash at whatever flash-to-subject distance is indicated for that aperture choice. In this case, I used my left hand to hold my flash about 3 feet to the left of the camera. (The flash was tethered by a simple coiled cord extending from the flash to the camera's hotshoe.)

24–85mm lens, f/11 for 1/200 sec. with Nikon SB-900 flash

determines the amount of flash light that hits your digital sensor (or film).

With all this in mind, how do you light up a subject in open shade against a background in full sunshine? First, set your aperture. Is depth of field important for your image? If it isn't, choose a "Who cares?" aperture of f/8 or f/11—good middle-of-the-road apertures for compositions that don't need a particularly deep or shallow depth of field.

Next, take a meter reading off the brighter background. In this case, chances are good that at f/11 and ISO 100, your meter will indicate 1/200 sec. for a correct exposure. Fire off a test exposure for the background to ensure that it looks perfect. Your subject in the foreground shade will still be too dark, but not to worry, as we are about to "shine the light" on that subject.

Now turn to your flash. I am a manual flash kind of guy, so in this example, I'd dial up f/11 on the back of my flash to match the aperture on the camera. The flash will then tell you what your flash-to-subject distance should be for that aperture. In this example, my flash would tell me that at f/11, my flash-to-subject distance should be roughly 6 feet. I'd then place my flash 6 feet from my subject. Next, with my flash held in my left hand, set to fire remotely, and at a distance of 6 feet from my subject, I'd press the shutter release. Voilà! A perfect exposure. I've exposed the subject with flash at f/11 at a 6-foot distance, and also recorded a perfect ambient exposure of the bright background at f/11 for 1/200 sec. See? It's easy!

Sometimes you'll want to isolate a subject in open shade by lighting her up while rendering portions of your bright background dark. For example, I was photographing a young model named Emily Carlson at seven fifteen in the morning near New York City's Brooklyn Bridge Park. I captured the first photograph (opposite, top right) with 100% natural light. If we take a close look at the overall scene, it is clear that Emily was in open shade and the distant background was in full sun. I wanted front-to-back sharpness, so I chose an aperture of f/16. Because I set a correct exposure for Emily, f/16 for 1/30 sec. at ISO 200, the background of full sun results in an overexposure. For the second photograph (opposite, far right bottom), I set a correct exposure for the background, f/16 for 1/200 sec., and just about everything in the open shade went dark, including Emily. But all of this black, underexposed area was actually a good thing, as you are about to see.

I called upon my flash, the Nikon SB-900. I dialed in f/16 on the back of my flash, and it indicated a flash-to-subject distance of 7.7 feet based on my use of ISO 200 and a flash-head zoom setting of 24mm. I attached the flash to a hot-shoe cord, which allowed me to hold the flash a bit high and to the left of the camera. With my flash exposure set, it would be a correct flash exposure as long as I pressed the shutter release when Emily was between 7 and 8 feet from the flash. But before doing that, I needed to determine what kind of ambient, natural-light exposure I want to record. The ambient exposure is controlled by both aperture and shutter speed, so it is fair to say that at f/16 for 1/200 sec., I would record *only* distant sunlight of the sky and the light on the bridge and *none* of the much dimmer light of the open shade. As Emily walked toward me, and just before she reached that 7- to 8-foot distance, she put her head down and then quickly tossed it back up. As her head turned upward, hair and all, the flash fired and recorded her hair "standing on end" against the dark and welcome contrast of a severely underexposed background of open shade (opposite, left).

Opposite, far right top: 24–85mm lens at 24mm, f/16 for 1/30 sec.; Opposite, far right bottom: 24–85mm lens at 24mm, f/16 for 1/200 sec.; Opposite, left: 24–85mm lens at 24mm, f/16 for 1/200 sec. with Nikon SB-900 flash

HOW TO EXPOSE A SUBJECT AGAINST A SUNSET OR SUNRISE SKY

The Challenge

A close look at any experienced photographer's portfolio will reveal striking portraits taken against the backdrop of a predawn sky or the red and magenta afterglow of a recent sunset. It is not just the colors of the sky that draw our attention but the contrast between the subject and the background. This contrast is most extreme when you use a flash to illuminate a subject in the foreground. The resulting image involves a striking interplay of light from the flash and dim-yet-colorful ambient light.

Unfortunately, the mere thought of mixing light sources intimidates many photographers. How do you apply the light? How do you avoid overexposing the subject, or severely underexposing the background? How do you match the color temperatures of the light?

The Solution

The first question to ask yourself, as always, is whether there are any depth-of-field concerns. Do you want a shallow depth of field or a deep depth of field, or do you not care? That decision will drive your aperture choice. Once you've chosen an aperture, you are ready for step 2: determining the right shutter speed to expose the sunset sky in the background.

With your aperture set and with the camera in manual exposure mode, simply point the camera to the sunset sky and adjust your shutter speed until a correct exposure is indicated. (Note that if the shutter speed is slower than the longest focal length of the lens you are using, you'll need to use a tripod to avoid camera shake. For example, if you're using a 24–85mm lens, a shutter speed slower than 1/85 sec. requires a tripod.) However, if you are using a lens with vibration reduction (VR) you can usually go an extra stop before resorting to the tripod; for example, 24–85mm VR means handholding is possible down to 1/40 sec. If you are using an IS or VR lens and placing the camera on a tripod, check to see if it is necessary to turn off the Image Stabilization or Vibration Reduction feature on the lens before using it on the tripod. Some IS or VR lenses, when left in the "on" position and when placed on the tripod, will actually create softness since the built in antishake mechanism is still operating even though the lens is now totally stable.

Now you're ready for step 3: setting up your flash to light the subject. If the flash is tethered to the camera via a flash cord or sitting in the camera's hot shoe, it will automatically "know" what aperture you are using. If not, enter the aperture you chose on the back of the flash. If the flash is in manual exposure mode, it will indicate a specific flash-to-subject distance for a perfect flash exposure. If your flash is in TTL mode, it will indicate a flash range, such as 3–12 feet. As long as your subject is within that distance range, you can expect a correct flash exposure.

Now, recompose your frame. Make sure your flash is within the stated distance range from the subject, and fire. You should record both a correct flash exposure and a correct ambient exposure at the same time! Are we having fun or what?

We were in our second day of a three-day workshop in Clarksdale, Mississippi, when one of the most surprising sunsets began to unfold. I say surprising because all day long it had been clear and sunny, not a cloud to be found, yet here it was, shortly after sunset, and high, swirling cirrus clouds appeared out of nowhere, creating a much more vivid sunset.

I wasn't about to let this scene slip by without photographing it. Luckily, Willy, a musician who had been playing his guitar just up the street from our location, agreed to pose. I chose an aperture of f/8 and took a meter reading off the sky, adjusting my shutter speed until 1/60 sec. indicated a correct exposure. As you can see in the first example (opposite), the sunset was correctly exposed but Willy was rendered as a silhouette, not a well-lit portrait.

It was time to call upon my Nikon SB-900 flash. After I dialed in f/8 on the back of the flash, it calculated a flash-to-subject distance of 13 feet for a correct flash exposure. Unfortunately, I was only about 5 feet from the subject, 8 feet too close. I could move back to the 13-foot distance or I could stay put and simply power down the flash. As I powered down the flash to 1/8 power, it indicated a flash-to-subject distance of 5 feet, so I was ready to shoot. After engaging Nikon's Commander mode, I was able to use the flash off camera and fire remotely. Handholding the flash in my right hand, I extended my arm out and toward Willy from a distance of roughly 5 feet. With the camera still set at the ambient exposure of f/8 for 1/60 sec., I fired the shutter release. As you can see in the second image (below), the result was a correct exposure of both the sky and Willy.

Both images: 24–85mm lens, f/8 for 1/60 sec., second image (below) with Nikon SB-900 flash

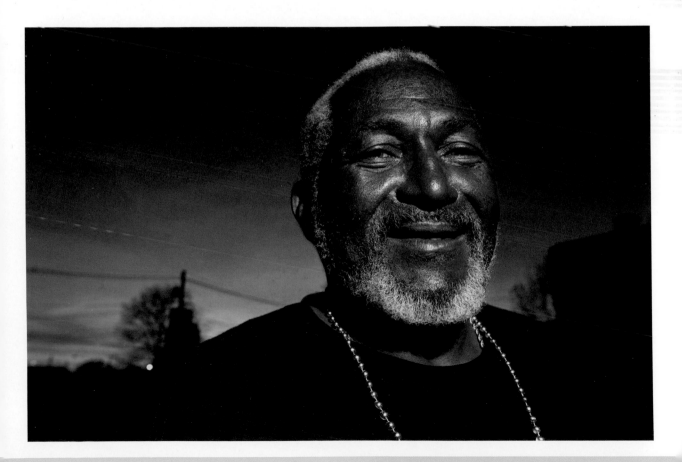

HOW TO USE FILL FLASH TO CAPTURE FLATTERING PORTRAITS IN MIDDAY SUN

The Challenge

Trying to capture a good portrait in the harsh sunlight of midday is not so much a challenge as much as a foregone conclusion. It just doesn't work. Shooting at midday typically gives you shadows around your subject's eyes (the "raccoon effect") from the direct overhead sunlight, as well as other pronounced shadows around facial features.

The Solution

Think of ambient light as the key light, or main light, and use fill flash as a secondary light to fill in the shadow areas and create a far more flattering image.

The key to shooting basic fill flash is to not shoot a flash exposure at the recommended setting but instead underexpose it by 1 stop while keeping your camera at the proper exposure. In other words, start by setting your camera to the ambient-light exposure, such as f/11 for 1/125 sec., but then set your flash to an aperture 1 stop smaller (in this example, f/16). This tricks the flash into thinking that it needs to put out less light, preventing it from overpowering the natural light and washing out the subject. This technique fills in the shadows nicely and lowers the dynamic range, giving the image a more natural and less "flashy" appearance.

Without the benefit of flash, the first image of this young girl at a camel festival in the United Arab Emirates (opposite, top) has all of the telltale signs of midday light: high-contrast light and dark areas, including dark, squinty eyes. The available light exposure of f/16 for 1/200 sec. rendered a "correct" exposure, but hardly a flattering one.

When I added flash to the second image (opposite, bottom), I filled in the shadow areas and created a far more pleasing image. As we know, the ambient-light exposure was f/16 for 1/200 sec. I dialed in f/16 on the back of the flash and it gave me a flash-to-subject distance of 6 feet for a correct exposure. That was good news since the young girl was about 6 feet from me. But if I had shot at this setting, the flash would have not only filled in the shadows but also overpowered the ambient light, resulting in an overexposure. Remember, I already had an exposure for the sunlight on her face; this would have been like adding more "sunlight" to the already brightly lit areas.

So I stopped down one aperture setting and dialed in f/22 on my flash. This reduced the flash-to-subject distance to 4 feet. Perfect! Instead of her receiving the full power of the flash from only 4 feet away, she got only about half of that flash power at 6 feet away (based on the inverse square law, see page 58). When it comes to fill light, you usually need only about half as much light as normal. In this case, setting the flash to f/22 reduced its power just enough to get my fill without overpowering the ambient-light exposure. As you can see in the second example, I got just enough fill to lighten up the shadows.

For those of you who prefer to use your flash in TTL mode, the simplest solution is to reduce your Exposure Value (EV) setting to -1. (Refer to your flash instruction manual if you don't know where to set the EV settings.)

Both images: 24–85mm lens, f/16 for 1/200 sec., second image (bottom) with Nikon SB-900 flash

HOW TO ISOLATE A FLOWER AGAINST A BLACK BACKGROUND

The Challenge

There are many ways to isolate a given subject. While the simplest is using a wide-open aperture for a very shallow depth of field, you may find that this technique sometimes leads to uneven lighting and/or uneven tones in the background. These tones can steal attention away from, rather than call attention to, your subject. One solution is to transform the background into a velvety black backdrop.

The Solution

The idea is to severely underexpose the ambient light in the background, creating a deep black pocket, while using an electronic flash as your sole light source to illuminate the flower. Remember, every ambient exposure is a combination of aperture and shutter speed, while a flash exposure is dependent only on the right aperture. A fast shutter speed will underexpose the ambient light only, while the flash illuminates the flower.

This technique is best done under cloudy skies, in open shade, or when light levels are lower, such as early morning or late afternoon. Use an aperture between f/8 and f/22, which will offer a good supply of shutter speed choices that will underexpose the ambient light without being too fast to sync with the flash. (The shutter speed must not exceed your flash's fastest sync speed, usually 1/200 sec. or 1/250 sec. Check your flash's manual to find out what it is.)

Start by choosing an aperture—let's say f/8. Then meter off the flower to determine what your shutter speed would be for a correct exposure. Now, *underexpose by 3 stops*. For example, let's say I choose an aperture of f/8. I meter off the flower and my camera indicates a correct exposure at 1/30 sec. If I increase my shutter speed to 1/250 sec., I have just set a 3-stop underexposure.

Then, fire up your flash. Enter the same aperture on the back of your flash (in this case, f/8) and it will indicate the correct flash-to-subject distance. If you keep your flash that distance from the subject, you will record a perfect flash exposure of the subject surrounded by a sea of darkness. That darkness is nothing more than the ambient light that is out of the range of the flash recorded as a 3-stop underexposure.

I isolated this bright red flower against a distant background at the garden center of a Home Depot in Chicago. With my aperture set to f/8, I adjusted my shutter speed until 1/25 sec. indicated a correct exposure. The resulting ambient-light exposure (opposite) is somewhat pleasing, but to truly isolate this geranium against a dark black background I would need my flash. I also needed to increase my shutter speed, thereby "killing" the ambient exposure of the background.

First, I increased my shutter speed by 3 stops to 1/200 sec. With my flash in manual mode, I entered an aperture of f/8 on the back of the flash and noticed that it indicated a flash-to-subject distance of 12 feet. I was only 3 feet from the flower, so I needed to power the flash down before I shot. After powering the flash down to 1/16 power, it told me that it would record a correct flash exposure at 3 feet away. With my lens set to f/8 and my shutter speed now 1/200 sec., I was ready. I held the flash to the left, pointing down toward the flower, and recorded the image shown below.

Opposite: 105mm lens, f/8 for 1/25 sec.; Below: 105mm lens, f/8 for 1/200 sec., Nikon SB-900 flash

HOW TO USE FILL FLASH TO ILLUMINATE DARK BACKGROUNDS

The Challenge

We've looked at photographing a subject in open shade with a bright background, but what about a subject in shade with a background that's in even deeper shade? If you expose for the foreground and the subject, your background fades into darkness. If you expose for the darker background, you could overexpose the subject. Fill flash could help illuminate your subject, but then everything behind it would fall into black. How can you create a universally well-exposed image with both the foreground subject and darkened background well lit, well exposed, and clearly visible?

The Solution

You might think of fill flash when your main subject is in harsh midday light, but what you may not realize is that it can also be used to shed light on dark backgrounds. If your ambient light provides enough illumination to light your subject, you can add a fill flash to the background to match the light level on the subject. The key is to set the exposure for the subject based on available light, and then add the fill flash to the background to match the foreground exposure.

We've already learned about the differences between manual flash and TTL flash (page 96), as well as how to determine your appropriate flash-to-subject distance in manual and your flash range in TTL (page 96). Those same principles apply here, only your subject—the area you are lighting—is the background. So when establishing your flash-to-subject distance or flash range, just remember that your flash needs to be the correct distance from the *background*, rather than from the subject.

Also, depending on the color of the light falling on your scene, you may want to add a colored gel to your flash to warm up the light. If you do this, you will need to compensate for the loss of light caused by placing the gel over the flash head. An amber gel, for example, detracts about 2/3 stop of light, so you'll need to move your flash closer to the background to compensate. How much closer? Well, if your flash-to-subject distance calls for 10 feet, you would move the flash to about 8 feet. In the world of flash, one full stop means cutting your distance by 25%. Since this is only 2/3 stop, simply adjust accordingly.

With these settings in place, when you trip your shutter, the fill-flashed background should match the ambient-light exposure of the subject in the foreground.

In the opposite image, my subject, Cliff, was sitting in open shade beneath an overhanging roof. The many items on display for sale behind him were also in open shade, but since they were farther back on the porch, they were in even darker shade than Cliff.

At f/8 for 1/90 sec. with no flash, I captured a pleasant exposure of Cliff (opposite, top left). Not surprisingly, the background behind him recorded quite dark, since 1/90 sec. wasn't enough time to correctly expose that part of the composition. Directing some fill flash onto the background area above Cliff, I lit up the background with just enough

light to match the available-light exposure of Cliff's face. I dialed in f/8 on my flash, and the distance scale indicated that the flash needed to be about 9 feet from the subject. I also added a light-amber gel to the flash to create a warmer light in the background. My son stood to the right of Cliff, holding the remote flash up high at a distance of about 9 feet while pointing it downward at a 45-degree angle. Then I fired away at f/8 for 1/90 sec. What was once hidden was revealed by the "sunlight" from my flash (opposite, bottom).

All images: 24–85mm lens at 45mm, f/8 for 1/90 sec., final shot with Nikon SB-900 flash

HOW TO USE FLASH TO CREATE ARTIFICIAL BACKLIGHT

The Challenge

Experienced portrait and fashion photographers often shoot in sunny locations early and late in the day, placing their subjects in front of the low-angled sun. The result is an angelic glow from the backlight shining around the subject's hair. Sometimes a portrait needs a little something extra, and this angelic glow adds just the needed punch.

Of course, a rising or setting sun is ideal for this backlight, but what if you're indoors, it's a cloudy day, or you're in a sheltered location? How can you get "sunshine" portraits when there is no sun to be found?

The Solution

By adding a touch of flash, of course! By setting up an electronic flash with a radio receiver behind your subject, you can remotely trigger the flash during your exposure to produce the effect of backlight.

Start by determining the aperture you'd like for your composition. Do you want a deep depth of field for a storytelling composition? A shallow depth of field for a single-theme composition? Or a "Who cares?" composition in the middle range? Then take a meter reading of the ambient light falling on the subject's face at your chosen aperture, adjusting the shutter speed until you get a correct exposure.

If you're using your flash in manual mode, enter the aperture on the back of the flash and see what flash-to-subject distance is indicated. If you're using it in TTL mode, you'll get a distance range instead. This is where things shift a little. You don't actually want a correct flash exposure, because you're trying to re-create the look of a strong light source, like the sun. Instead, you want a brighter light that will cause a gross flash overexposure. If the sun really was behind the subject's head and you metered off the face, you would get a strongly overexposed rim light around the head from the bright sun behind the subject. *That's* the look we want to emulate. With this in mind, set up your flash closer than the flash-to-subject distance indicated (about twice as close, in fact, to simulate the much brighter background of sunlight) and then trigger it with a remote trigger.

You'll need an assistant or a light stand to hold your flash behind your subject, aimed at your subject's back. You may also want to add an amber gel to the flash to provide a warmer, sunsetlike appearance. If you do this, however, just remember to position the flash at least twice as close to the subject as what is called for (see page 108).

In an effort to convey the power of this really cool trick, I deliberately chose to shoot a "backlit sunset portrait" inside a covered parking garage. First I determined that since the entire frame was filled with the subject's face, depth of field was not an issue, so I chose a "Who cares?" aperture of f/8. Then I took a meter reading of the ambient light falling on the model's face and adjusted the shutter speed until a correct exposure was indicated at 1/125 sec.

My assistant and fellow photographer Robert LaFollette stood about 3 feet behind our model and held up the flash, which I'd covered with an amber gel so that it would provide a warm, sunsetlike flash. With my flash and camera both set to manual, and with the flash at full power (1/1), the flash indicated a 15-foot flash-to-subject distance for a correct exposure. However, as I already mentioned, Robert was only 3 feet behind our model. Was he too close?

In this case, no, because I did not want a correct flash exposure. In fact, I wanted the flash exposure to be substantially overexposed so that the viewer's eye would be fooled into thinking there was a sun setting behind the subject. I knew that if I placed the flash about 3 feet behind the subject's head (pointed toward her hair), a gross flash overexposure would result. So with Robert holding the light about that distance behind the subject, I made my exposure and fired the flashes remotely with a PocketWizard transceiver system.

70–300mm lens, f/8 for 1/125 sec., Nikon SB-900 flash

Shortly into my Tucson workshop, I engaged the help of one of my students, Leslie Hammond, who is also an accomplished photographer and designer. We found ourselves shooting in and around Tucson City Hall with stunning color just about everywhere you looked. My eyes caught sight of a stairway and a single overhead light, which was not on. However, with a bit of ingenuity, we could make that light look like it was shining from overhead and backlighting Leslie's hair.

The first photograph (below) is a simple ambient exposure of f/22 for 1/60 sec. As you can see, there is no flash and no overhead light on behind Leslie.

Now look at the second example (right). Same exposure. Same setup. The only difference is a flash that I fired from directly behind Leslie, pointed straight up to light up the white dish of the overhead light as well as the back of Leslie's hair. The effect makes the light appear to be on, while providing a pleasing backlight that calls attention to Leslie's radiating smile.

With one PocketWizard attached to my flash and another mounted on the camera's hot shoe, I fired the flash remotely as I made my second exposure. Another student, Stan McPartland, crouched behind Leslie and held the flash about 3 feet from her back.

Both images: 12–24mm lens at 16mm, f/22 for 1/60 sec., second image (right) with Nikon SB-900 flash

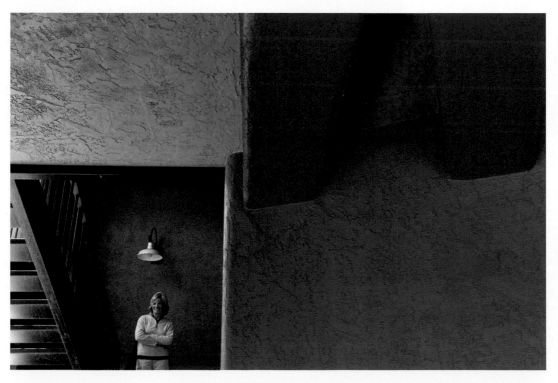

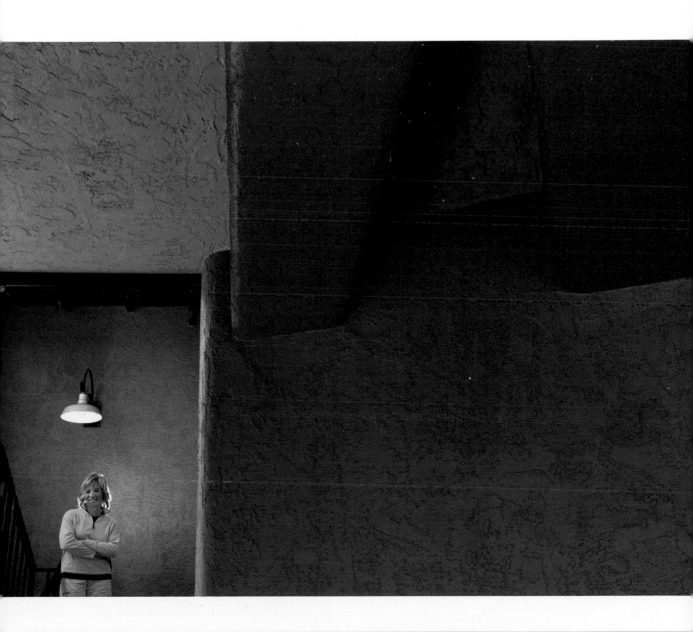

HOW TO ILLUMINATE DARK FOREGROUND OBJECTS WHEN THERE'S A BRIGHTER BACKGROUND

The Challenge

When shooting landscapes, you're often faced with variable lighting, particularly when photographing at dawn, at dusk, or when the light is otherwise coming from a low angle. Often, you'll find that your background is brightly illuminated by low-angled sunlight, yet elements in your foreground have fallen into shadow. If you make a simple exposure, metering off the background, your foreground will record as a dark silhouette devoid of any detail. Forget those interesting rocks or colorful flowers; they're now an unrecognizable mass or dark shapes. If you want a storytelling image with a full beginning (foreground), middle (middle ground), and end (background), you need to find a way to illuminate those foreground elements in a way that matches the rest of the composition.

The Solution

Start with the same techniques we discussed for deep depth-of-field storytelling images (page 12). Pick a small aperture, such as f/22, set your focus to the near point of your range of focus (usually 3 feet or 6 feet), and then take a meter reading off of the sky, which is often much brighter than the landscape, to determine the appropriate shutter speed. With these exposure settings ready to go, compose your shot. Now it's time to add your flash.

If you're using your flash in manual mode, plug in the aperture on the back of the flash to get your flash-to-subject distance. If you're in TTL, the flash will give you a distance range. Make sure your flash is set up at the specified distance (or within the distance range) from the foreground subject you want to illuminate.

Depending on the color of the light falling on your background, you may want to add a colored gel to your flash to warm up the light. Just remember that a gel will cause a loss of light from the flash (an amber gel detracts about 2/3 stop of light). To compensate for the reduced light, move the flash closer to the subject to maintain a correct flash exposure.

From Alki Point near Seattle, you get a really nice view of the downtown Seattle skyline. Although photographers often use a moderate telephoto for skyline photos, I wanted to shoot a storytelling composition that included this blooming bush in the foreground with the distant Seattle skyline and the city's typical gray skies overhead. Because a storytelling composition is dependent on a great depth of field (see page 12), I needed a small aperture, such as f/16 or f/22. My goal was to create a correct flash exposure while still recording a correct storytelling exposure.

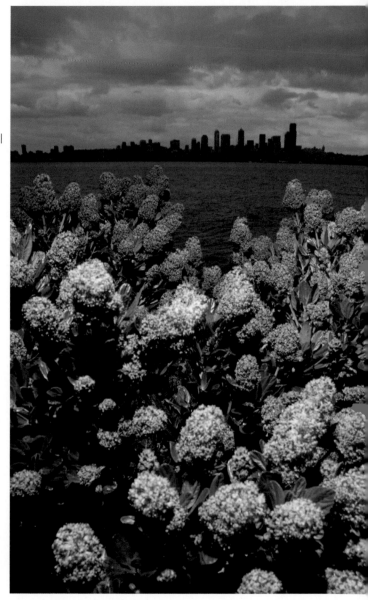

 With my lens aperture set to f/22 and the flash set to full power, I dialed up f/22 on the back of my flash and zoomed the flash head to 18mm. At these settings, my Nikon SB-900 flash indicated a 4.7-foot flash-to-subject distance for a correct flash exposure. I mounted my Nikon D3X and 16–35mm lens on a tripod, chose a focal length of 18mm, turned off autofocus, and preset the focus to 3 feet. (To learn more about where to focus when shooting storytelling compositions, see page 12.)

 I took a meter reading off the distant ambient exposure of the gray sky and adjusted my shutter speed until 1/125 sec. indicated a 1-stop underexposure. The underexposure would impart a darker sky than in reality, and this darker sky would serve up a welcome dose of contrast to the soon to be brightly lit flowers. I took a test shot without any flash to confirm that this was the exposure I wanted. Although it was a gray day, it was still late in the afternoon and the area surrounding my foreground was a much darker area than the distant city skyline. Directly behind the bushes was a tall hillside that blocked some of the light from the bright but dull gray western sky. As a result, the foreground flower bush required a much longer exposure time to render a correct exposure—a shutter speed of 1/15 sec. However, since I would be lighting the flowers with *supplemental* light, a correct exposure of these flowers was dependent only on the right flash-to-subject distance, based on the aperture of f/22. Using my PocketWizard Plus II wireless transceiver to trigger my off-camera flash, I held the flash in my left hand, raised about 4 feet above the flowers, and fired the shutter for a perfect exposure at f/22 for 1/125 sec (right).

Both images: 16–35mm lens, f/22 for 1/125 sec., second image (right) with Nikon SB-900 flash

As the sun set across this idyllic scene at the Vermilion Lakes near Banff, in Alberta, Canada, I encountered a challenge that only a flash could solve. Because I wanted a deep depth of field, I chose an aperture of f/22 on my 16–35mm Nikkor zoom lens. With my focus preset to 3 feet, I simply aimed the camera to the sky and adjusted my shutter speed until 1/60 sec. indicated a correct exposure. As you can see in the first example (above), the landscape is silhouetted except for a small part of the mountain illuminated by the low-angled sidelight of the setting sun. I felt the visual weight of this composition was unbalanced. It needed some "sunlight" on the small rock in the foreground.

I grabbed my flash and set it to f/22, which produced a flash-to-subject distance of 5.6 feet. However, because the low-angled sunlight on the distant mountain was very warm, I needed to ensure that my flash would produce that same warm light. I added an amber-colored gel to the flash head, turning the normally white light of the flash into a much warmer tone. The amber gel causes a 2/3-stop loss of light from the flash, much like a filter, so I needed to shorten the flash-to-subject distance accordingly.

With the flash pointed at the small rock in the foreground from a distance of about 3 feet, and with the same exposure as the previous photo (f/22 for 1/60 sec.), I pressed the shutter release. Just as I had hoped, the foreground rock lit up for a much more balanced and pleasing composition (right).

Both images: 16–35mm lens, f/22 for 1/60 sec., second image (right) with Nikon SB-900 flash

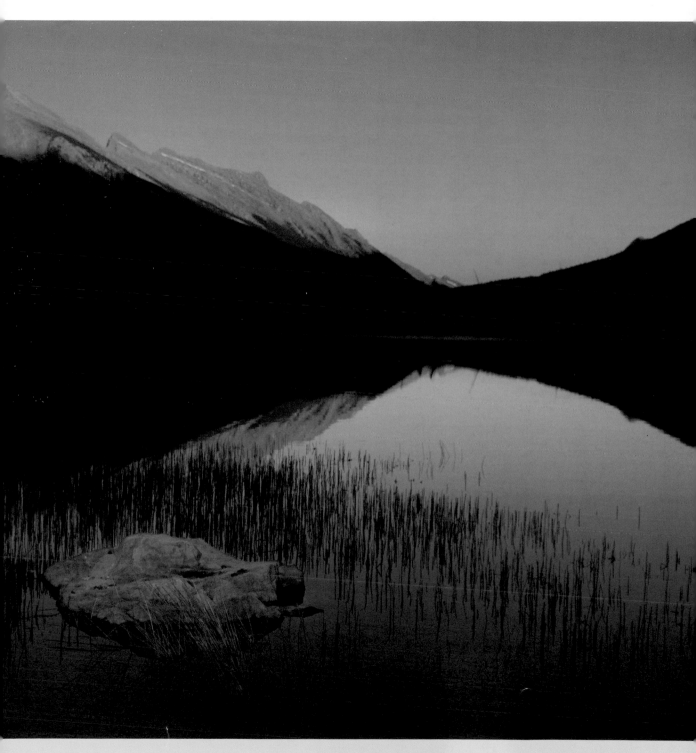

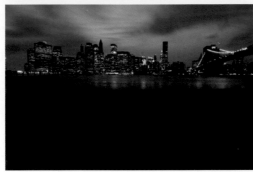

Standing just next to New York City's Brooklyn Bridge, my eyes caught sight of the word GORGEOUS on the fence along the pier, with the Manhattan skyline in the background (daylight view shown above, top). This was a classic storytelling image, so f/22 was the clear aperture choice. With my Nikon D3X and 16–35mm lens at the 19mm focal length, I manually set the focus to 3 feet (1 meter) on the distance scale and then took a meter reading off of the sky. At this point, it was 20 minutes after sunset. With my ISO set to 100, my meter indicated a shutter speed of 15 seconds for a correct exposure of the ambient light.

As you can see from the second image (above, bottom), however, this correctly exposed the skyline but not the foreground, which was lost. So out came my Nikon SB-900 flash. I placed an amber gel on the flash to warm up the blue-gray railing. With the flash set to manual exposure mode, I set the aperture dial on the back of my flash to f/22 and zoomed the flash to 18mm. The flash indicated 4.6 feet as the flash-to-subject distance for a correct exposure. I fired the camera, and during the 15-second exposure of the ambient light, I manually tripped the flash that I handheld about 4 feet above GORGEOUS at about a 30-degree angle. The third image (right) shows the result. Easy stuff, really.

All images: 16–35mm lens, f/22 for 15 seconds, third image (right) with Nikon SB-900 flash

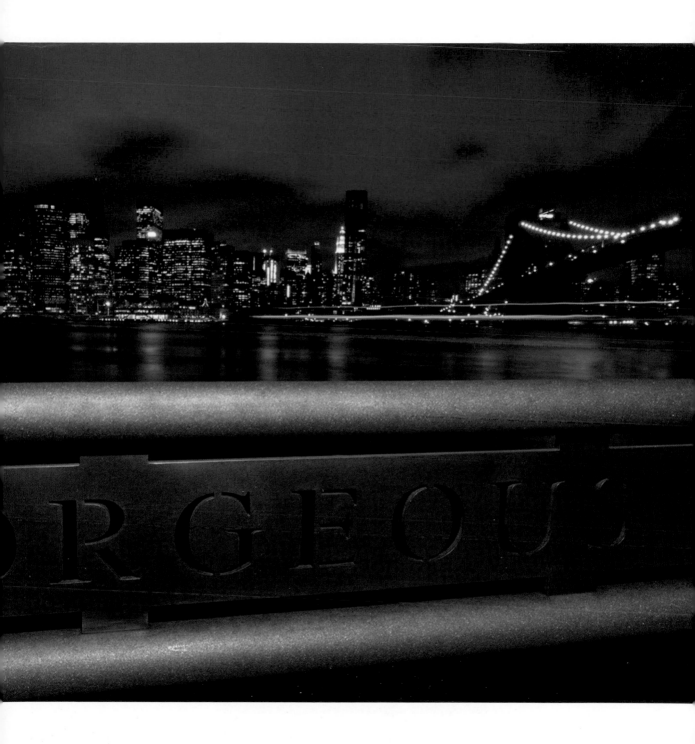

RECORD BLUER SKIES WITH YOUR FLASH

When using your flash in the great outdoors, set your white balance to Tungsten/Incandescent and place an amber gel on your flash. The areas lit by the flash will record as daylight, but the distant sky will record a more vivid Tungsten/Incandescent blue.

Lying down between several rows of tulips, I set my aperture at f/11 and metered off the distant sky, adjusting my shutter speed until 1/125 sec. indicated a correct exposure. This correctly exposed the sky, but the tulips in the foreground would have been underexposed since they are not as bright as the sky above.

Using my flash to light the tulips, I was presented with two options: (1) record the sky naturally, or (2) record a much bluer sky. Fortunately, I could do both, thanks to a simple white balance change and an amber gel.

When using gels it is important that you know how much the flash output is reduced by the gel. In the case of this gel, which was a medium amber, the loss of flash output was about 2/3 stop.

I was approximately 2 feet from the tulips, and at f/11, I had to power down the flash to 1/16 power to get 2 feet as the correct flash-to-subject distance. However, I had to adjust for the amber gel, which would eat some of that light, so I turned the flash back up to 1/8 power, which yielded a flash-to-subject distance of 3.4 feet. In effect, the flash was telling me to back off to 3.4 feet, but because I was using the gel, I could shoot from only 2 feet away without overexposing the subject. Holding the flash along with an attached PocketWizard, I pointed it up a bit at the tulips and clicked the shutter at f/11 for 1/125 sec. As you can see in the first image (below), I made a correct exposure of the tulips with a faint blue sky. The warm tones on the tulips are because of the warm flash output from the amber gel.

Are you ready for a bluer sky? All I needed to do was change the white balance from Cloudy to Tungsten/Incandescent. As you can see in the second image (right), this switch produced a much bluer sky.

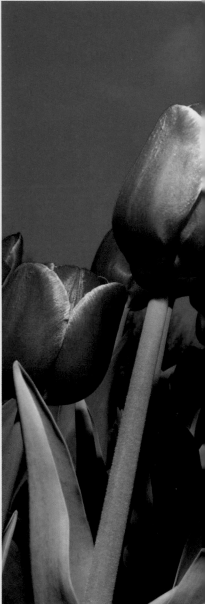

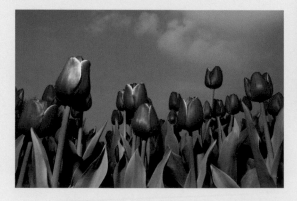

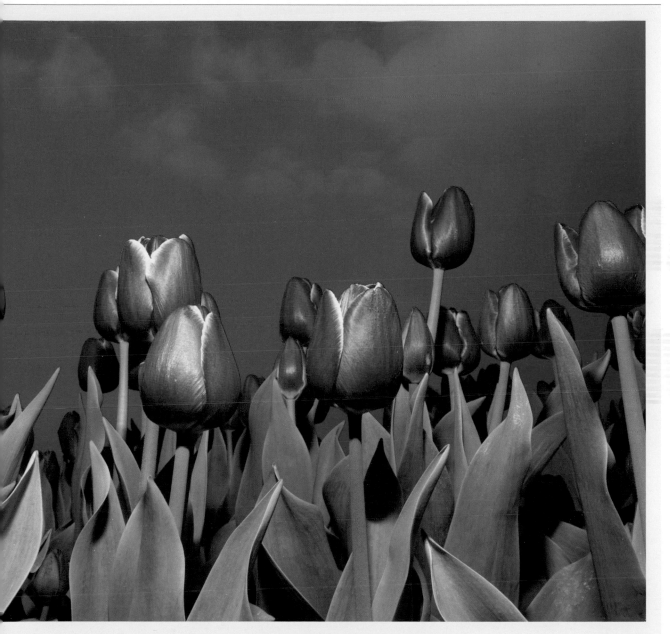

Left: 16–35mm lens at 20mm, f/11 for 1/125 sec., Cloudy white balance; Above: 16–35mm lens at 20mm, f/11 for 1/125 sec., Tungsten white balance

MAKING ARTISTIC EXPOSURES

The world is full of fun and exciting exposures, many of which you might not think of as "common photography challenges." Nevertheless, these artistic exposures offer a chance to experiment, broaden creative horizons, and hone exposure techniques in an alternate format. In this section, we'll look at some not-so-ordinary exposures that make a day—or night—out with a camera truly entertaining. Who knows? Maybe these chapters will inspire some new artistic techniques for you!

HOW TO CAPTURE "GHOSTS"

The Challenge

Capturing a "ghost" on your digital sensor (or film) can be trickier than it looks. How long should you expose in hopes of recording the spirit? How do you maintain sharpness in the surrounding scenery while still portraying the fluid movement of your ethereal subject? Most important, how do you turn an image of what may look like a normal person into a paranormal photograph full of ghostly movement and energy?

The Solution

The first place to go looking for ghosts is, of course, the very places where ghosts love to hang out: old Victorian-style homes, basements, and your bedroom closet. Ghosts usually come out only at night, or at the very least when light levels are low, so that means long exposures. You'll need to bring your tripod. Ghosts are shy by nature, and I have found that it takes about 8 seconds for them to reveal themselves. It's also important that you stand very still, since any disturbance to the air can cause the ghost to flee.

Your ghost needs to move in coordination with your exposure time. In some ghost images, you may want your subject to stand still for a portion of the exposure and then move quickly out of the frame for the remainder of the exposure. This will record the person's image in a translucent form, because the space in which the subject was standing will record as blank scenery once he or she has moved on. I often have my ghost subjects stand still for the first half of the exposure, and then move during the second half.

CREATE A GHOSTLY IMAGE

Here's an idea if you are looking for the perfect Halloween party invitation. First, mock up the front page of a newpaper with a headline that reads GHOSTS SEEN TAKING OVER [YOUR NEIGHBORHOOD]! Around dusk, grab a few family members or friends and place one of them on a park bench, preferably under or near a streetlight. Ask the subject on the bench to hold the newspaper as if she is reading it, with the front-page headline facing you since it is imperative that the viewer sees the headline. Ask your other models to stand behind the bench, looking over the shoulder of the person reading the newspaper. Set up an 8-second exposure. Ask the "ghosts" to leave after the first 4 seconds, while the person on the bench remains still for the entire 8 seconds. Sure enough, you now have your Halloween party invitation!

When I lived in France, I found myself going into the "cave" of my apartment building. For too many nights I had been awakend by the soft yet howling voice of what I thought to be a child in distress, and it was time to investigate. With my tripod-mounted camera set to ISO 100 and a 12–24mm lens, I established the composition you see here. I plugged in an aperture of f/8 and adjusted my shutter speed until 8 seconds indicated a correct exposure. As you can see, it didn't take long for me to get my ghost picture, and just as I suspected, it was the ghost of a little girl.

Of course I'm joking. The idea for this shot was born after both of my daughters watched the movie *The Ring*. When

I told Chloë and Sophie how easy it was to make our own ghosts, they were all ears. Outfitted in a white dress and no shoes (much to the chagrin of her mother), Sophie stood in the dirt floor hallway of the basement in our apartment building, holding perfectly still for the first 4 seconds of my 8-second exposure. At the end of 4 seconds, she bolted out of the picture, to her left, where there is another short hallway. Because she was in the shot for only half of the exposure time, she was recorded as a transparent, ghostlike subject. Pretty neat, eh?

12–24mm lens, f/8 for 8 seconds

HOW TO PAINT
WITH SHUTTER SPEED

The Challenge

Until recently, the most-repeated rules of thumb in photography were to keep the horizon line straight and, above all else, make sure the image is in focus. It was unthinkable for a photographer to deliberately handhold a camera at a very slow shutter speed without the aid of a tripod. Those who did were often scoffed at for producing blurry images. Fortunately, times have changed, and the idea of "painting" with a slow shutter speed has been embraced.

Painting with a slow shutter speed is a hit-or-miss affair. There's a fine line between self-made art and a hot mess of blurriness. It takes practice getting used to the patterns of movement and how they work during an exposure, and it's easy to end up with images that are more of a big smudge than interesting artistic photographs.

The Solution

Painting with shutter speed is actually a simple technique; the challenge is finding the right subject to paint. Once you have a subject, simply set a correct exposure that will allow you to use a shutter speed of 1/4 or 1/2 sec. This often means choosing a small aperture or using a filter to reduce the light falling on the digital sensor. Polarizing and ND filters decrease the intensity of the light, thus allowing a slower-than-normal shutter speed while still maintaining a correct exposure. With your aperture and/or filter set, you're ready to "paint." As you press the shutter release, twirl, arch, jiggle, or jerk the camera up and down, side to side, or in a circular motion.

Flower gardens make ideal candidates for this type of "painting." But don't overlook other compositional patterns, such as harbors, fruit and vegetable markets, even the crowd at a football game. Also, consider painting with shutter speed in low light, where shutter speeds can range from 2 to 8 seconds. The difference here is that your movement of the camera should be slower. The resulting image can look as if you used a palette knife to layer and smear paint as the exposure time builds one blurred image layer upon another.

The simple and colorful hanging flower box shown at left provided a welcome opportunity to create an energy-filled composition. Standing over a portion of the flower box, I envisaged a composition reminiscent of my youth when I would squirt paints on a paper and spin it for several seconds to reveal a kaleidoscope of colors. So how did I do this with a camera?

First I pulled out my 16–35mm wide-angle lens and a 2- to 8-stop ND filter. With my lens set to the focal length of 20mm and fitted with my filter, I set a correct exposure of f/11 for 1/4 sec. As I pressed the shutter release, I rotated the camera in a right-to-left circular motion, as if drawing a circle. At the same time, with my other hand, I zoomed the lens from 20mm to 35mm. All of this took place in 1/4 sec., so I needed to be quite fast.

16–35mm lens, f/11 for 1/4 sec. with 2- to 8-stop ND filter

This technique is not limited to flowers. During a bike-a-thon in Vancouver, British Columbia, I stood close to the curb with my 16–35mm lens. As the cyclists came by, I spun the camera while zooming at the same time, shooting at 1/4 sec. in Shutter Priority mode with the aid of my 3-stop ND filter. Normally f/22 is an aperture associated with deep depth of field, but depth of field is never a concern in shots like this since any sharpness will get blurred out because of the spinning and moving of the camera.

16–35mm lens, f/22 for 1/4 sec. with 3-stop ND filter

One spring, while on the Greek Island of Santorini, I spent the better part of a full afternoon photographing the lupines and daisies that seemed to grow all the way down the hillside to the deep blue Aegean Sea. I was fully immersed in a Monet mentality and shooting with carefree abandon. I tried a host of slow shutter speeds coupled with varying motions—up and down, side to side, herky-jerky. I am absolutely certain that anyone who saw me from a distance would have assumed that I was in a constant fight with the local honeybees, as my arms were in a constant flailing motion.

Note in the photograph below the somewhat archlike effect, as if the flowers were jumping or flying. I achieved this effect simply arching the camera, quickly, during my 1/4-sec. exposure.

35–70mm lens, f/22 for 1/4 sec. with 4-stop ND filter

For me, the fall of 2006 in the southwest corner of Maine proved to be one of the most colorful I have ever witnessed. I had just finished a short morning hike in the mountains, feeling quite accomplished with what I had already photographed, when I spotted this simple stand of trees.

I made the first normal exposure (above, left) with my camera and 70–300mm lens set to f/16 for 1/125 sec., at ISO 100. I made the second exposure with the same camera and lens, but added a 2- to 8-stop ND filter to my lens, which caused a light loss of 6 stops. To recover these 6 stops, I simply readjusted my shutter speed from 1/125 sec. down to 1/2 sec. so that my meter once again indicated a correct exposure. I also stopped the aperture down by 1 full stop, to f/22, which meant I needed to double my exposure again from 1/2 sec. to 1 second to return to a correct exposure. This extra stop would of course give me a shutter speed twice as long, and in this case I felt the longer the better! (Practice and your own personal taste will help you decide when to use an extra stop or two.) Then I pressed the shutter release and slowly moved the camera upward in a smooth, flowing motion. The result was the streaks of color and texture that you see in the second image (above, right).

In the third exposure (opposite), I achieved a different effect by combining this "Monet" technique with a multiple exposure and a faster speed. By going into the camera's menu and selecting "multiple exposure, nine times," I told the camera to shoot nine exposures, all overlapping one another on a single frame. (This multiple-exposure feature can be found on many current Nikon, Pentax, and Canon DSLRs.) I removed the ND filter and returned to my initial exposure of f/16 for 1/125 sec. While holding down the camera's shutter release during the nine exposures, I moved the camera ever so slightly, a tiny bit to the left, a touch to the right, slightly up and down. This produced a kind of pallette-knife, painterly effect.

For this technique to work, it is essential to set a correct exposure as if you are shooting just one shot, even though you are shooting multiple exposures. Your camera's autogain feature will blend the exposures into a single image and render that final image as correctly exposed. It doesn't get any easier than that!

Above left: 70–300mm lens, f/16 for 1/125 sec.; Above right: 70–300mm lens, f/22 for 1 second with 2- to 8-stop ND filter; Opposite: 70–300mm lens, f/16 for 1/125 sec. shot nine times and auto blended into one exposure

HOW TO ADD ENERGY WITH SIMPLE ZOOMING

The Challenge

Let's say you're out shooting a scene and you want to spice it up with some extra energy and movement. Maybe it's a scene that's been photographed many times by many photographers and you want to do something different. Or maybe the elements of the scene just aren't providing that extra punch that you want in your image. What do you do?

The Solution

One of the most overlooked ways to bring life and movement to otherwise stationary subjects is by simply twisting the zoom lens during a relatively slow exposure. Tripod or no tripod, the choice is yours (personally I prefer to use the tripod for simple zooms as it results in a cleaner image), and just like those spinning, twirling, or jerking images covered in the previous section, there is no shortage of subjects.

To make one of these exposures, pick a subject and set up your composition. Select a small enough aperture to force a longer shutter speed; it should be at least 1/4 sec., but can be several seconds long. When you click the shutter release, zoom your lens from the widest angle to the narrowest in one fluid motion. The resulting image will look as if the scene is sliding toward you in a dramatic tunnel, almost like you're jumping into warp speed in an old sci-fi movie.

Atop the staircase in the heart of Times Square, I stood with my tripod-mounted camera and 70–300mm lens. With the aid of a 2- to 8-stop Tiffen ND filter and an ISO of 100, I set my aperture to f/11 and adjusted my shutter speed until 1/4 sec. indicated a correct exposure. As soon as I pressed the shutter release, I turned the zoom ring of the lens from 70mm toward 300mm. After making about ten attempts, I felt confident that I had two or three that did, in fact, convey the energy and buzz for which Times Square is known.

Opposite: 70–300mm lens, f/11 for 1/4 sec. with 2- to 8-stop ND filter

In New York City's Brooklyn Bridge Park, I composed what is surely one of the most common images of New York City at dusk. With my camera and 24–85mm lens mounted on a tripod, I set the aperture to f/11 since depth of field was not a concern. With my focal length at 60mm, I pointed the camera toward the dusky magenta-blue sky above the city and adjusted my shutter speed until 2 seconds indicated a correct exposure. I then recomposed the scene and fired off several frames, one of which you see here (above). Following this exposure, I made several more, still at f/11 for 2 seconds, but this time slowly zooming my lens from 60mm to 85mm, creating a rather explosive image of the New York City skyline (right). I like to call it "the zoom with a boom."

Both images: 24–85mm lens, f/11 for 2 seconds

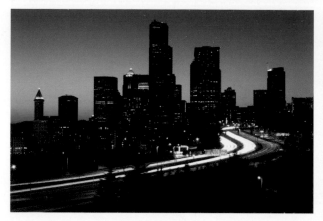

There is another zoom technique to consider when shooting exposures in the 8- to 16-second range. Take a look at these two images of the Seattle skyline and Interstate 5. I captured the first image (above) without zooming the camera at all. With my camera and 70–300mm lens mounted securely on a tripod, and with my aperture set to f/16, I pointed the camera to the dusky sky above the skyscrapers and adjusted the shutter speed until 8 seconds indicated a correct exposure. I then depressed my cable release, and this was the result.

In the second photograph (right), I chose to do something a bit different. I thought it would be interesting to see what would happen if I made three separate "exposures" at three different focal lengths during the 8-second exposure. With my exposure setting of f/16 for 8 seconds, I fired the shutter release and waited for 2 seconds, then carefully and quickly moved the focal length from 100mm to 135mm, counted 2 seconds, then moved the focal length from 135mm to 200mm, counted 2 seconds, and finally moved the focal length to 240mm for the remaining 2 seconds of the exposure. Sure enough, if you look closely, you can see four distinct "exposures" of the Seattle skyline.

Both images: 70–300mm lens, f/16 for 8 seconds

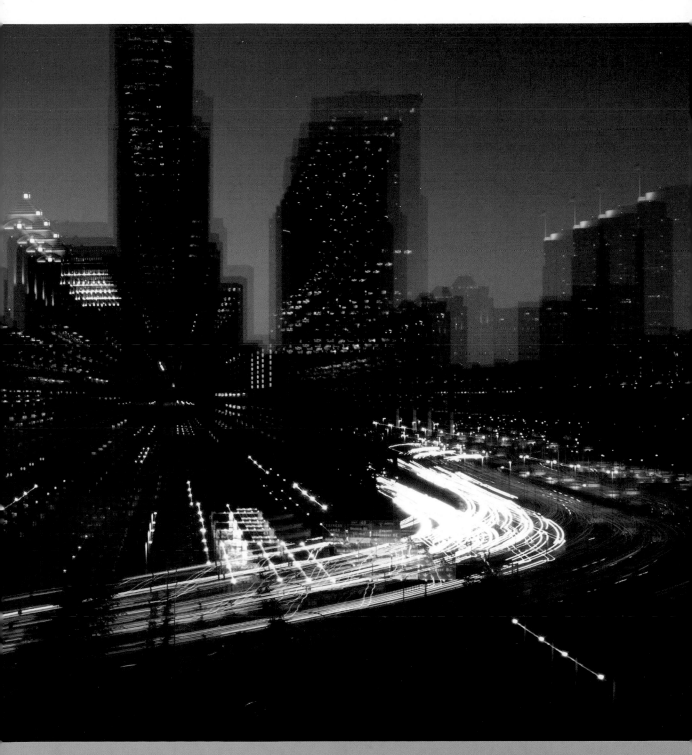

HOW TO PAINT
WITH LIGHT

The Challenge

If you can think of the digital sensor as a blank canvas (a good habit to get into), it might be easier to appreciate the sometimes surprising results of light painting. In the normal everyday world of image-making, most of us associate exposure with shutter speeds that are faster than the blink of an eye. However, when it comes to light painting, the exposure times are more often seconds and sometimes even minutes. Unlike an actual painter who uses oils or acrylics to decorate a canvas, a light painter employs flashlights, sparklers, and electronic flash with colored gels. Depending on the time of day you choose to begin your light painting, you will also find yourself, on occasion, calling on your 2- to 8-stop variable ND filter.

The Solution

Much of light painting is trial and error; sometimes success comes easily, while other times it seems elusive no matter how hard you try. But as a general rule, effective light painting relies on exposure times of 8–60 seconds. Your exposure time will be determined by the time of day (and the ambient light present in your scene), your choice of aperture, your ISO, and any filters you choose to use, including the ND filter. Most people conduct their light painting at dusk or around dawn, or in a darkened room. In all three of these situations, the light levels are low. When combined with an ISO of 200 or 100

and an aperture of f/16 or f/22, exposure times will generally range from 15 to 30 seconds. If you add an ND filter, your shutter speed may stretch to 1 minute and beyond. The size of the area you wish to "paint" will usually determine exactly how long your exposure time should be.

To set up one of these exposures, start by estimating the amount of time you'll need to paint your subject with light. Once you've determined that time, adjust your aperture until you've reached the correct exposure at your target time. For example, if I start with a correct exposure of f/11 for 4 seconds, and I estimate that I'll need 8 seconds to achieve my light painting effect, I will stop down my lens to an aperture of f/16 so that the meter indicates a correct exposure at 8 seconds. This also explains why I always pack my Vivitar 2- to 8-stop variable ND filter, since I can use it to add even more time to my exposure if necessary.

Whether you're at the beach, desert, mountains, city, or your own backyard, the opportunity to paint with light presents itself every day around dawn and again shortly after sunset. It does not matter what time of year it is, or if it's cloudy, clear, raining, or snowing. All that matters is that you use no less than an 8-second exposure.

What if you're shooting during the day? With the aid of a 2- to 8-stop variable ND filter, you can quickly turn day into night, creating exposures that are normally thought possible only in low light or at night.

In a small wooded area near Christchurch, New Zealand, I picked up a feather off the forest floor and placed it between an opening in the bark of a large fir tree, as you can see in the first photo (above). I then placed a 2- to 8-stop ND filter on my macro lens. After rotating the filter to achieve the maximum density, I stopped down the lens to f/22 and plugged in an ISO of 100. These settings gave me the correct values for an 8-second exposure.

Tripping the shutter, I slowly moved my flashlight up and down across the feather, producing the glow you see in the second image (left). It's important to note that I chose to shoot this feather with my white balance on cloudy. This created a much warmer, golden light on the feather.

Above: 105mm lens, f/16 for 4 seconds with 2- to 8-stop ND filter; Left: 105mm lens, f/22 for 8 seconds with 2- to 8-stop ND filter

I am not a fan of shooting city scenes once the skies turn black. In fact, about 25 minutes after sunset you will see me packing up my camera bag and heading home. As I mentioned on page 38, a black sky rarely provides the necessary contrast between buildings and sky. On the other hand, you will find me working feverishly during the 10-minute window of dusky blue sky that occurs just after sundown, as I did on this particular evening in New York City. (The 10 minutes right after sunrise also present prime shooting time.)

I set up this shot of Jill Sipkins, one of the instructors at ppsop.com, from a hotel room overlooking 34th Street. What looks like a complicated exposure was actually quite easy thanks to the use of a simple flashlight. To be clear, we did not light 34th Street with a flashlight but rather used the flashlight to light Jill as she sat in a chair in a corner of the room.

I set up my composition to include the view of 34th Street on the left and the soon-to-be "painted" Jill on my right. With my camera and 16–35mm lens on a tripod, I aimed my camera so that the frame included only the window and the scene outside and took a meter reading, setting my exposure to f/11 for 8 seconds. I then recomposed to frame the scene you see here and tripped the shutter. As Jill sat in the darkened room, she held perfectly still as I began painting her with an ordinary flashlight. I moved the illuminated flashlight in an up-and-down, side-to-side fashion, making certain to light only those areas of Jill that I wished to record during my exposure. As you can see, both Jill and the city street below recorded as a correct exposure because I exposed for the outside scene and then "painted" in Jill with the help of a flashlight and a long exposure.

Many of my students would ask, why not just use your electronic flash to light up Jill? A flash would not only light up Jill, but also the entire room, changing the mood of the image from mysterious to stark and jarring.

16–35mm lens, f/11 for 8 seconds

During a workshop in New Zealand, a willing student posed for us against the remnants of an impressive sunset that had taken place 15 minutes earlier. With my aperture set to the smallest opening, f/22, I metered off of the sky behind my model and adjusted my shutter speed until 15 seconds indicated a correct exposure.

While the model stood still with his arms outstretched, I quickly made an outline of his body with two flashlights, one covered with a blue gel and the other with a red gel. Then, with a third flashlight covered in a yellow gel, I made a swirling motion with my hand as I walked out of the frame during the final 2 seconds.

12–24mm lens, f/22 for 15 seconds

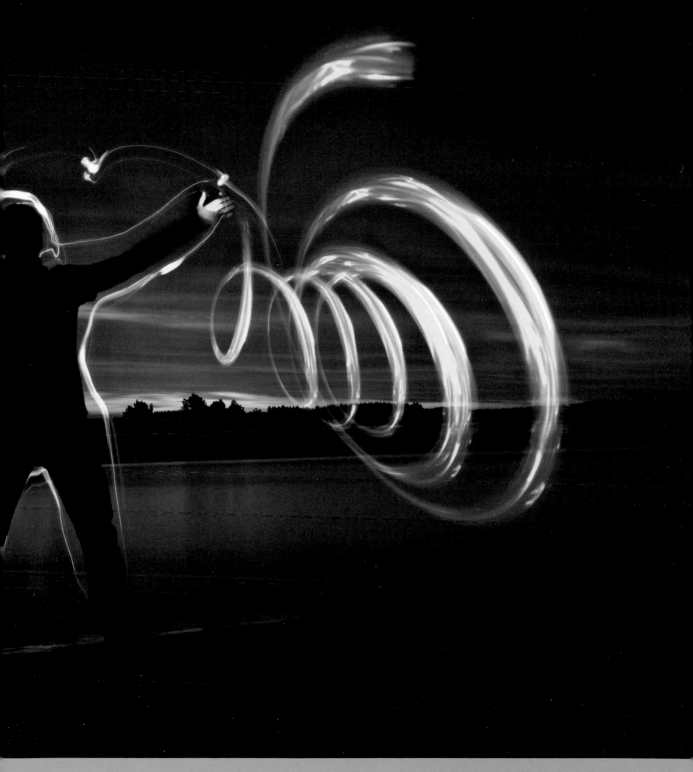

INDEX